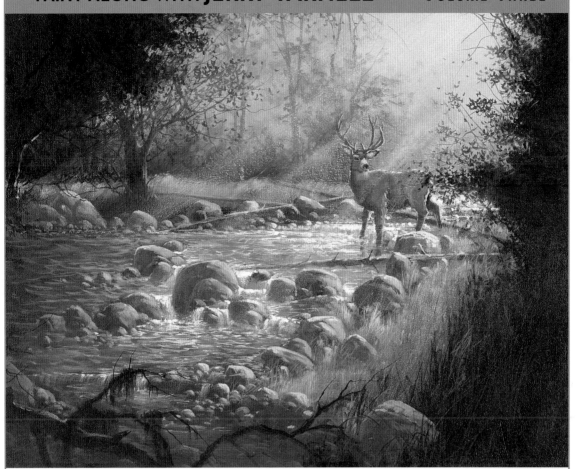

PAINTING
Magic

NORTH
LIGHT
BOOKS

CINCINNATI, OHIO
www.artistsnetwork.com

ABOUT THE AUTHOR Jerry Yarnell was born in Tulsa, Oklahoma, in 1953. A recipient of two scholarships from the Philbrook Art Center in Tulsa, Jerry has always had a great passion for nature and has made it a major thematic focus in his painting. He has been rewarded for his dedication with numerous awards, art shows and gallery exhibits across the country. His awards include the prestigious Easel Award from the Governor's Classic Western Art Show in Albuquerque, New Mexico, acceptance in the top one hundred artists represented in the national Art for the Parks Competition, an exhibition of work in the Leigh Yawkey Woodson Birds in Art Show and participation in a premier

showing of work by Oil Painters of America at the Prince Gallery in Chicago, Illinois.

Jerry has another unique talent that makes him stand out from the ordinary: He has an intense desire to share his painting ability with others. For years he has held successful painting workshops and seminars for hundreds of people. Jerry's love for teaching also keeps him very busy holding workshops and giving private lessons in his new Yarnell School of Fine Art. Jerry is the author of four books on painting instruction, and his unique style can be viewed on his popular PBS television series, *Jerry Yarnell School of Fine Art,* airing worldwide.

Other fine North Light Books are available from your local bookstore, art supply store or direct from the publisher.

10 8

Library of Congress Cataloging-in-Publication Data

Yarnell, Jerry
 Paint along with Jerry Yarnell.
 p. cm.
 Includes Index.
 Contents: v. 3. Painting Magic
 ISBN 13: 978-1-58180-180-4 (pbk.:alk. paper)
 ISBN 10: 1-58180-180-7 (pbk.:alk. paper)
 1. Acrylic painting—Technique. 2. Landscape painting—Technique. I. Title

ND1535 .Y37 2001
751.4'26—dc21 00-033944
 CIP

Editors: Maggie Moschell and Catherine Cochran
Designer: Joanna Detz
Production coordinator: Kristen Heller
Production artist: Linda Watts
Photographers: Scott Yarnell and Christine Polomsky

F+W PUBLICATIONS, INC.

DEDICATION

It was not difficult to know to whom to dedicate this book. I give God all the praise and glory for my success. He blessed me with the gift of painting and the ability to share this gift with people around the world. He has blessed me with a new life after a very close brush with death. I am here today and able to share all of this with each of you because we have a kind, loving and gracious God. Thank you, God, for all you have done.

Also to my wonderful wife, Joan, who has sacrificed and patiently endured the hardships of an artist's life. I know she must love me or she would not still be with me. I love you, sweetheart, and thank you. Lastly, to my two sons, Justin and Joshua: You both are a true joy in my life.

ACKNOWLEDGMENTS

So many people deserve recognition. First I want to thank the thousands of students and viewers of my television show for their faithful support over the years. Their numerous requests for instructional materials are really what initiated the process of producing these books. I want to acknowledge my wonderful staff, Diane, Scott, and my mother and father for their hard work and dedication. In addition, I want to recognize the North Light staff for their belief in my abilities.

FOR MORE INFORMATION

about the Yarnell Studio & School of Fine Art and to order books, instructional videos and painting supplies contact:

Yarnell Studio & School of Fine Art
P.O. Box 808
Skiatook, OK 74070

Phone: (877) 492-7635

Fax: (918) 396-2846

gallery@yarnellart.com

www.yarnellart.com

METRIC CONVERSION CHART

TO CONVERT	TO	MULTIPLY BY
Inches	Centimeters	2.54
Centimeters	Inches	0.4
Feet	Centimeters	30.5
Centimeters	Feet	0.03
Yards	Meters	0.9
Meters	Yards	1.1
Sq. Inches	Sq. Centimeters	6.45
Sq. Centimeters	Sq. Inches	0.16
Sq. Feet	Sq. Meters	0.09
Sq. Meters	Sq. Feet	10.8
Sq. Yards	Sq. Meters	0.8
Sq. Meters	Sq. Yards	1.2
Pounds	Kilograms	0.45
Kilograms	Pounds	2.2
Ounces	Grams	28.4
Grams	Ounces	0.04

Table of Contents

High and Mighty

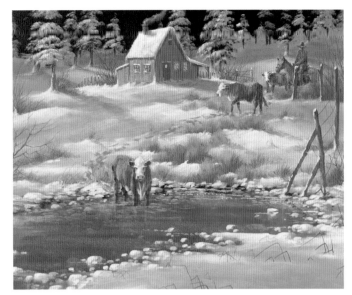

The Crossing

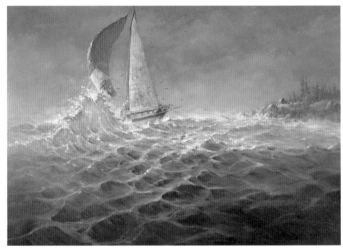

Tossed by the Waves

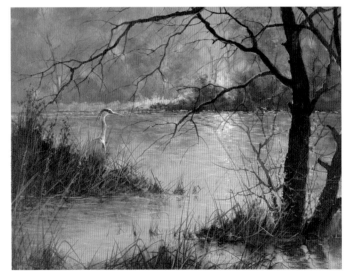

Patient Fisherman

Misty Morning Sunrise

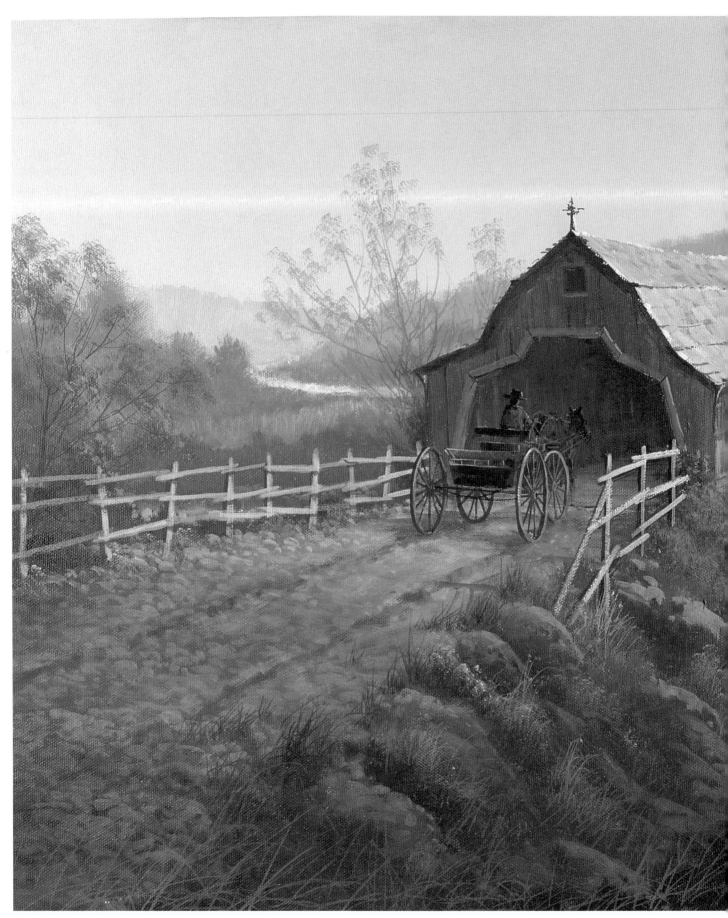

The Return to Days of Old
16" X 20" (40.6cm x 50.8cm)

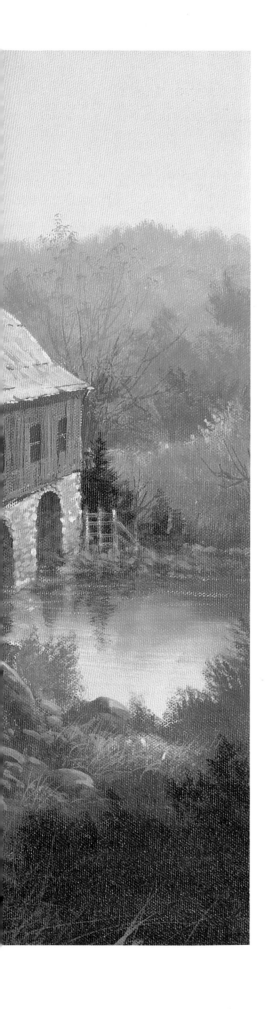

Introduction

When I think about the purpose of this book, I realize that it is all about experience. Once you have reached a point in your art career where you have a good basic understanding of all the technical aspects of painting like composition, design, perspective, negative space, color mixing, values and color coordination in terms of understanding the complementary color system, then it's a practical matter of applying these painting principles by doing numerous studies and practice paintings, until you are comfortable and secure in your understanding of all of them. This is called an advanced instructional book, not so much because these are extremely difficult, but because the paintings are designed to challenge your artistic abilities. Each painting will give you a unique set of artistic challenges to overcome. My goal as an instructor is not only to teach these principles, but to inspire, encourage and help build your confidence. There is a saying by an unknown author: "Success is gained by hard work, discipline, and not a little pain." So, don't be afraid to dive in headfirst and begin to gain experience and confidence.

Terms & Techniques

Before beginning the step-by-step instructions on the following pages, you may want to refresh your memory by reviewing these painting terms, techniques and procedures.

COLOR COMPLEMENTS

Complementary colors are always opposite each other on the color wheel. Complements are used to create color balance in your paintings. It takes practice to understand the use of complements, but a good rule of thumb is to remember that whatever predominant color you have in your painting, use its complement or a form of its complement to highlight, accent or gray that color.

For example, if your painting has a lot of green in it, use its complement, red, or a form of red such as orange, red-orange or yellow-orange. If you have a lot of blue in your painting, use blue's complement, orange, or a form of orange such as yellow-orange or red-orange. The complement to yellow is purple or a form of purple. Keep a color wheel handy until you have memorized the color complements.

DABBING

This technique is used to create leaves, ground cover, flowers, etc. Take a bristle brush and dab it on your table or palette to spread out the ends of the bristles like a fan. Then load the brush with an appropriate color and gently dab on that color to create the desired effect. (See above example.)

DOUBLE LOAD OR TRIPLE LOAD

This is a procedure in which you put two or more colors on different parts of your brush. You mix these colors on the canvas instead of on

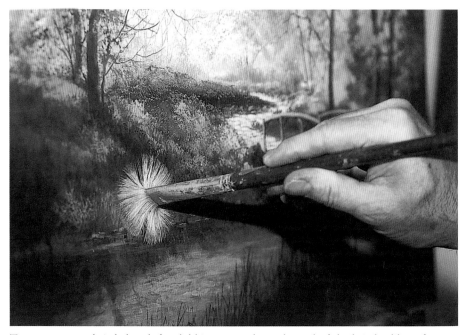

To prepare your bristle brush for dabbing, spread out the end of the bristles like a fan.

your palette. This is used for wet-on-wet techniques, such as sky or water.

DRYBRUSH

This technique involves loading your brush with very little paint and lightly skimming the surface of the canvas to add color, blend colors or soften a color. Use a very light touch for this technique.

EYE FLOW

This is the movement of the viewer's eye through the arrangement of objects on your canvas or the use of negative space around or within an object. Your eye must move or flow smoothly throughout your painting or around an object. You do not want your eyes to bounce or jump

from place to place. When you have a good understanding of the basic components of composition (design, negative space, "eye stoppers", overlap, etc.), your paintings will naturally have good eye flow.

FEATHERING

Feathering is a technique for blending to create very soft edges. You achieve this effect by using a very light touch and barely skimming the surface of the canvas with your brush. This is the technique to use for highlighting and glazing.

GESSO

Gesso is a white paint used for sealing the canvas before painting on it. However, because of its creamy con-

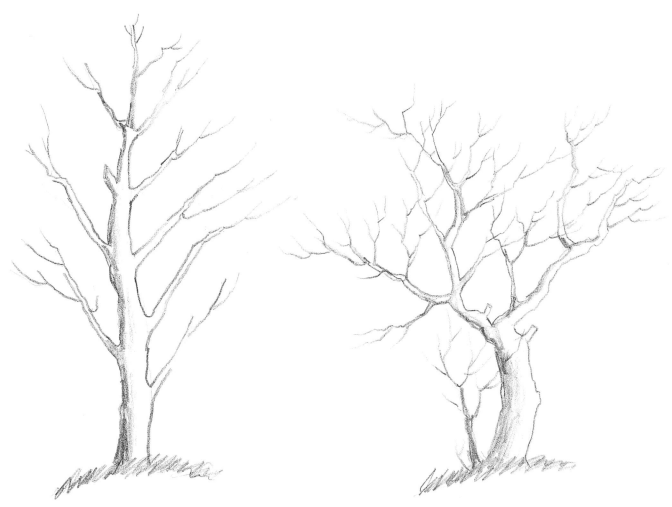

Here is an example of poor use of negative space. Notice the limbs do not overlap but are evenly spaced instead. There are few pockets of interesting space.

Here is an example of good use of negative space. Notice the overlap of the limbs and the interesting pockets of space around each limb.

sistency, I often use it instead of white paint; it blends so easily. I often refer to using gesso when mixing colors. Keep in mind that when I use the word gesso, I am referring to the color white. If you don't use gesso for white, use Titanium White paint, which is the standard white that is on the supply list. Please feel free to use it if you prefer.

GLAZE (WASH)

A glaze or a wash is a very thin layer of paint applied on top of a dry area of the painting to create mist, fog, haze, sun rays or to soften an area that is too bright. This mixture is made up of a small amount of color diluted with water. It may be applied in layers to achieve the desired effect. Each layer must be dry before applying the next.

HIGHLIGHTING OR ACCENTING

Highlighting is one of the final stages of your painting. Use pure color or brighter values of colors to give your painting its final glow. Highlights are carefully applied on the sunlit edges of the most prominent objects in paintings.

MIXING

While this is fairly self-explanatory, there are a couple of ways to mix. First, if there is a color that will be used often, it is a good idea to pre-mix a quantity of that color to have it handy. I usually mix colors of paint with my brush, but sometimes a palette knife works better. You can be your own judge.

I also mix colors on the canvas. For instance, when I am underpainting grass, I may put two or three colors on the canvas and scumble them together to create a mottled background of different colors. Mixing color on the canvas also works well when painting skies. (Note: When working with acrylics, always try to mix your paint to a creamy consistency that can be blended easily.)

NEGATIVE SPACE

This is the area of space surrounding an object that defines its form. (See example above.)

You can change the value of a color by adding white.

SCRUBBING

Scrubbing is similar to scumbling, except the strokes are more uniform in horizontal or vertical patterns. You can use dry-brush or wet-on-wet techniques with this procedure. I use it mostly for underpainting or blocking in an area.

SCUMBLING

For this technique, use a series of unorganized, overlapping strokes in different directions to create effects such as clumps of foliage, clouds, hair, grasses, etc. The direction of the stroke is not important.

UNDERPAINTING OR BLOCKING IN

These two terms mean the same thing. The first step in all paintings is to block in or underpaint the darker values of the entire painting. Then you begin applying the next values of color to create the form of each object.

VALUE

Value is the relative lightness or darkness of a color. To achieve depth or distance, use lighter values in the background and darker values as you come closer to the fore-ground. Raise the value of a color by adding white. To lower the value of a color, add black, brown or the color's complement.

WET-ON-DRY

This is the technique I use most often in acrylic painting. After the background color is dry, apply the topcoat over it by using one of the blending techniques: drybrushing, scumbling or glazing.

WET-ON-WET

In this painting technique, the colors are blended together while the first application of paint is still wet. I use the large hake (pronounced ha KAY) brush to blend large areas of wet-on-wet color, such as skies and water.

Getting Started

Acrylic Paint

The most common criticism about acrylics is that they dry too fast. Acrylics do dry very quickly through evaporation. To solve this problem I use a wet palette system, which is explained later in this chapter. I also use very specific dry-brush blending techniques to make blending very easy. If you follow the techniques I use in this book, with a little practice you can overcome any of the drying problems acrylics seem to pose.

Speaking as a professional artist, acrylics are ideally suited for exhibiting and shipping. An acrylic painting can actually be framed and ready to ship thirty minutes after it is finished. You can apply varnish over acrylic paint or leave it unvarnished because the paint is self-sealing. Acrylics are also very versatile because the paint can be applied thick or creamy to resemble oil paint, or thinned with water for watercolor techniques. The best news of all is that acrylics are non-toxic, have very little odor and few people have allergic reactions to them.

USING A LIMITED PALETTE

As you will discover in this book, I work from a limited palette. Whether it is for my professional pieces or for instructional purposes, I have learned that a limited palette of the proper colors can be the most effective tool for painting. This palette works well for two main reasons: First, it teaches you to mix a wide range of shades and values of color, which every artist must be able to do; second, a limited palette eliminates the need to purchase dozens of different colors. As we know, paint is becoming very expensive.

So, with a few basic colors and a little knowledge of color theory you can paint anything you desire. This particular palette is versatile, so that with a basic understanding of the color wheel, the complementary color system and values, you can mix thousands of colors for every type of painting.

For example, you can mix Thalo Yellow-Green, Alizarin Crimson and a touch of white to create a beautiful basic flesh tone. These same three colors can be used in combination with other colors to create earth tones for landscape paintings. You can make black by mixing Ultramarine Blue with equal amounts of Dioxazine Purple and Burnt Sienna or Burnt Umber. The list goes on and on, and you will see that the sky is truly the limit.

Most paint companies make three grades of paints: economy, student and professional. The professional grades are more expensive but much more effective to work with. The main idea is to buy what you can afford and have fun. (Note: If you can't find a particular item, I carry a complete line of professional–and student-grade paints and brushes. Check page 3 for resource information.)

MATERIALS LIST

Palette

White Gesso
Grumbacher, Liquitex or Winsor & Newton paints (color names may vary):

- Alizarin Crimson
- Burnt Sienna
- Burnt Umber
- Cadmium Orange
- Cadmium Red Light
- Cadmium Yellow Light
- Dioxazine Purple
- Hooker's Green Hue
- Thalo (Phthalo) Yellow-Green
- Titanium White
- Ultramarine Blue

Brushes

2" (51mm) hake brush
no. 4 flat sable brush
no. 4 round sable brush
no. 4 script liner brush
no. 6 bristle brush
no. 10 bristle brush

Miscellaneous Items

Sta-Wet palette
water can
no. 2 soft vine charcoal
16" × 20" (41cm × 51cm) stretched canvas
paper towels
palette knife
spray bottle
easel

Brushes

My selection of a limited number of specific brushes was chosen for the same reasons as the limited palette: versatility and economics.

2-INCH (51MM) HAKE BRUSH

The hake (pronounced ha KAY) brush is a large brush used for blending. It is primarily used in wet-on-wet techniques for painting skies and large bodies of water. It is often used for glazing as well.

NO. 10 BRISTLE BRUSH

This brush is used for underpainting large areas—mountains, rocks, ground or grass—as well as dabbing on tree leaves and other foliage. This brush also works great for scumbling and scrubbing techniques. The stiff bristles are very durable so you can be fairly rough on them.

NO. 6 BRISTLE BRUSH

A cousin to the no. 10 bristle brush, this brush is used for many of the same techniques and procedures. The no. 6 bristle brush is more versatile because you can use it for smaller areas, intermediate details, highlights and some details on larger objects. The no. 6 and no. 10 bristle brushes are the brushes you will use the most.

NO. 4 FLAT SABLE BRUSH

Sable brushes are used for more refined blending, detailing and highlighting techniques. They work great for final details and are a must for painting people and detailing birds or animals. They are more fragile and more expensive, so treat them with extra care.

NO. 4 ROUND SABLE BRUSH

Like the no. 4 flat sable brush, this brush is used for detailing, highlighting, people, birds, animals, etc. The main difference is that the sharp point allows you to have more control over areas where a flat brush will not work or is too wide. This is a great brush for finishing a painting.

NO. 4 SCRIPT LINER BRUSH

This brush is my favorite. It is used for the very fine details and narrow line work that can't be accomplished with any other brush. For example, use this brush for tree limbs, wire and weeds—and especially for your signature. The main thing to remember is to use it with a much thinner mixture of paint. Roll the brush in an ink-like mixture until it forms a fine point.

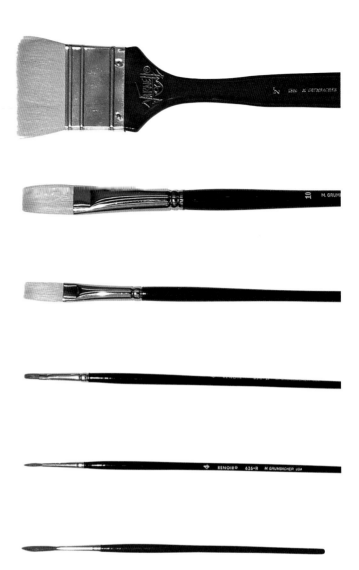

With this basic set of brushes, you can paint any subject.

BRUSH CLEANING TIPS

Remember that acrylics dry through evaporation. As soon as you finish painting, use good brush soap and warm water to thoroughly clean your brushes. Lay your brushes flat to dry. If you allow paint to dry in your brushes or your clothes, it is very difficult to get it out. I use denatured alcohol to soften dried paint. Soaking the brush in the alcohol for about thirty minutes, then washing it with soap and water, usually gets the dried paint out.

The Palette

There are several palettes on the market designed to help keep your paints wet. The two I use extensively are Sta-Wet palettes made by Masterson. Acrylics dry through evaporation, so keeping the paints wet is critical. The first palette is a 12" × 16" (31cm × 41cm) plastic palette-saver box with an airtight lid. This palette comes with a sponge you saturate with water and lay in the bottom of the box. Then you soak the special palette paper and lay it on the sponge. Place your paints out around the edge and you are ready to go. Use your spray bottle occasionally to mist your paints and they will stay wet all day long. When you are finished painting, attach the lid and your paint will stay wet for days.

My favorite palette is the same 12" × 16" (31cm × 41cm) palette box, except I don't use the sponge or palette paper. Instead, I place a piece of double-strength glass in the bottom of the palette. I fold paper towels into long strips (into fourths), saturate them with water and lay them on the outer edge of the glass. I place my paints on the paper towel. They will stay wet for days. I occasionally mist them to keep the towels wet.

If you leave your paints in a sealed palette for several days without opening it, certain colors, such as green and Burnt Umber will mildew. Just replace the color or add a few drops of chlorine bleach to the water in the palette to help prevent mildew.

To clean the glass palette, allow it to sit for about thirty seconds in water or spray the glass with your spray bottle. Scrape off the old paint with a single-edge razor blade. Either palette is great. I prefer the glass palette because I don't have to change the palette paper.

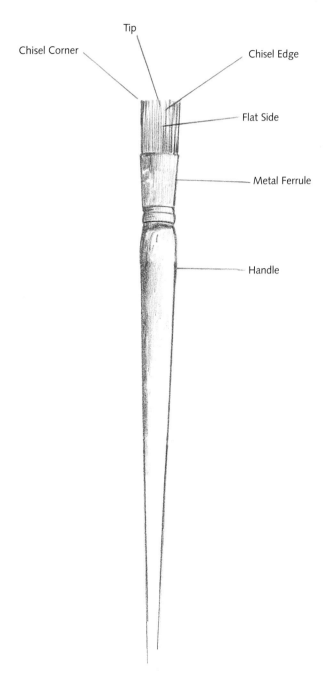

Brush diagram

Setting Up Your Palette

Here are two different ways to set up your palette.

Palette 1

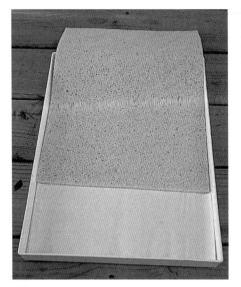

The Sta-Wet 12" × 16" (31cm × 41cm) plastic palette-saver box comes with a large sponge, which is saturated with water.

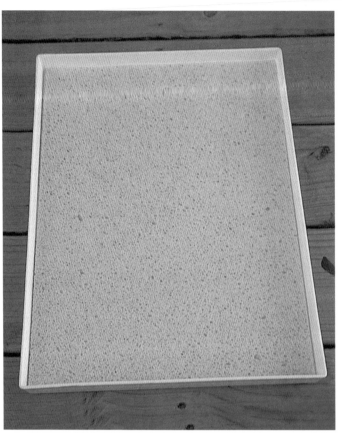

Lay the sponge inside the palette box. Next, soak the special palette paper and lay it on the sponge. Place your paints around the edge. Don't forget to mist your paints to keep them wet.

The palette comes with an airtight lid.

When closing the palette-saver box, make sure the lid is on securely. When the palette is properly sealed, your paints will stay wet for days.

Palette 2

Lay the saturated paper towels on the outer edges of the glass.

Instead of using the sponge or palette paper, another way to set up your palette box is to use a piece of double-strength glass in the bottom of the palette. Fold paper towels in long strips and saturate them with water to hold your paint.

I place my paints on the paper towel in the order shown.

Use the center of the palette for mixing paints. Occasionally mist the paper towels to keep them wet.

To clean the palette, allow it to sit for thirty seconds in water or spray the glass with a spray bottle. Scrape off the old paint with a single-edge razor blade.

Miscellaneous Supplies

CANVAS

There are many types of canvas available. Canvas boards are fine for practicing your strokes, as are canvas paper pads for doing studies or for testing paints and brush techniques. The best surface to work on is a primed, prestretched cotton canvas with a medium texture, which can be found at most art stores. As you become more advanced in your skills, you may want to learn to stretch your own canvas. I do this as often as I can, but for now a 16" × 20" (41cm × 51cm) prestretched cotton canvas is all you need for the paintings in this book.

EASEL

I prefer to work on a sturdy standing easel. There are many easels on the market, but my favorite is the Stanrite ST500 aluminum easel. It is lightweight, sturdy and easy to fold up to take on location or to workshops.

LIGHTING

Of course, the best light is natural north light, but most of us don't have this light available in our work areas. The next best light is 4' or 8' (1.2m or 2.4m) fluorescent lights hung directly over your easel. Place one cool bulb and one warm bulb in the fixture: this best simulates natural light.

Studio lights

16" × 20" (41cm x 51cm) stretched canvas

Aluminum Stanrite studio easel

SPRAY BOTTLE

I use a spray bottle with a fine mist to lightly mist my paints and brushes throughout the painting process. The best ones are plant misters or spray bottles from a beauty supply store. It is important to keep one handy.

PALETTE KNIFE

I do not do a lot of palette-knife painting. I mostly use a knife for mixing. A trowel-shaped knife is more comfortable and easier to use than a flat knife.

SOFT VINE CHARCOAL

I prefer to use soft vine charcoal for most of my sketching. It is very easy to work with and shows up well. It is easy to remove or change by wiping it off with a damp paper towel.

Spray bottle

Soft vine charcoal

Palette knives

A Word about Mahlsticks and the Stedi Rest System

All of us at one time or another will have days when we are not as steady as we would like to be. Perhaps you are working on something that requires a lot of close-up detail work, or your painting is still wet and you can't steady your hand on the canvas while painting. The solution to these problems is called a mahlstick. I use it along with a little gadget called a Stedi Rest.

These photos show the use of a mahlstick both with and without the Stedi Rest. Either way, a mahlstick is a "must" for most painters. Really, a mahlstick is nothing more than a dowel rod about 36" (91cm) long that can be purchased from any hardware store. The Stedi Rest must be purchased from an art store. I carry both items at my studio for my students, which can be accessed online at my web site: www.Yarnellart.com. The mahlsticks I stock are handmade from special woods and finishes.

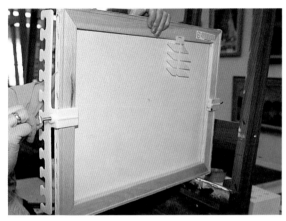

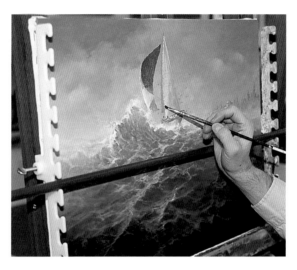

Attaching the Stedi Rest is a simple matter of screwing the bracket on the side of your stretcher strip.

Attaching a Stedi Rest on each side of the painting will give you several different horizontal positions.

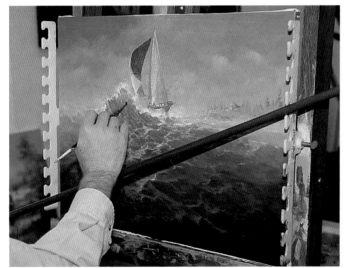

Using your mahlstick on only one side of the Stedi Rest will give you several different angles from which to work.

The mahlstick can be used without the Stedi Rest by placing it at the top of the canvas to give you more vertical positions.

Understanding Complements

By the time you begin studying these books, you may have had some experience with the color wheel. However, I have noticed that many students still don't have a clear understanding of complements, the value system and graying colors. I would like to spend a little time discussing these issues as they pertain to landscapes. Note: There is much more in-depth study of the color wheel in my technique book.

Most landscape painters use a color wheel of grayed complements. As you probably know, a standard color wheel is made up of three primary colors—red, yellow, blue—three secondary colors—green, violet, orange—and six tertiary colors (intermediate colors)—red-orange, yellow-orange, yellow-green, blue-green, blue-violet, red-violet. In their pure forms, these colors are too bright to do a traditional landscape. Most artists create their own version of a grayed color wheel. For my color wheel, I use Hooker's Green, Cadmium Red Light and Cadmium Yellow Light as my primary colors, and mix the secondary and intermediate colors from these. Often we need to gray the colors to achieve the desired effect. We gray a color by adding its complement or a form of its complement.

For example, you want to use Hooker's Green, but it looks too intense for a particular area of your painting. Simply add some of its complement, which is found on the opposite side of the color wheel. You could add touches of Cadmium Red Light, Cadmium Orange, red-violet, red-orange, yellow-orange, etc. These are all forms of complements to Hooker's Green. Use this process for all of the colors. To gray purple, add yellows or forms of yellow. To gray orange, add blue or forms of blue, and so on around the wheel.

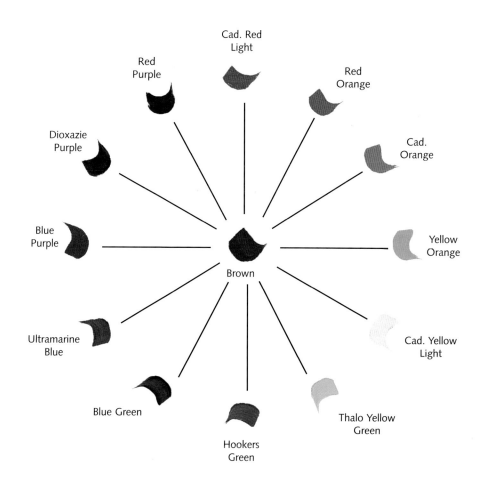

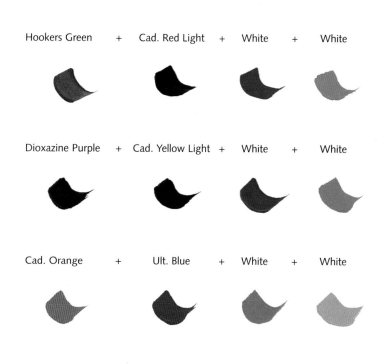

The Crossing
16" × 20" (40.6cm × 50.8cm)

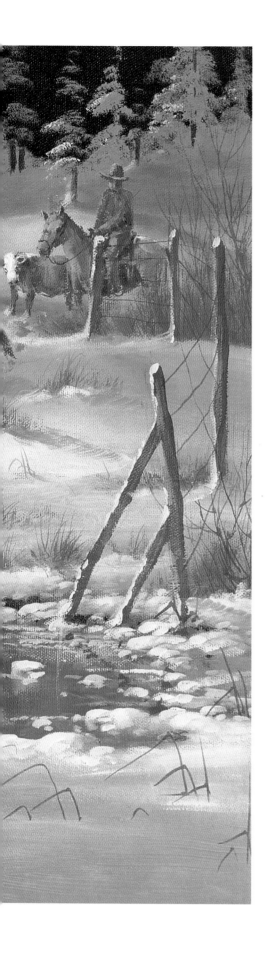

The Crossing

My first dream as an artist was to live on a ranch and become a western artist. Well, half of the dream came true. I have had the good fortune of becoming a full-time professional artist; however, the ranch part is still a dream. Nevertheless, I love the West, and find great joy in painting cowboys, horses and cows; and winter is my favorite season. Although I was able to satisfy my personal artistic desires in this painting, its main purpose is to be instructional for you. The main focus is learning to create a cold, snowy atmosphere, along with the clear transparent water. Add subject matter such as the cattle, horse and cowboy, and I think you'll find that this painting will really challenge your artistic abilities. There is much to learn here, so be patient, and you will have great success!

1 Make Charcoal Sketch

Begin with a very basic charcoal sketch using your soft vine charcoal. If you've read my other books, you'll know that I do most of my drawing with a brush, and so all you will need here is just three main contour lines.

2 Underpaint Background Pine Trees

With the high horizon and dense forest, this underpainting is simple. On your palette, using your no.10 hake brush, mix Hooker's Green with a fourth as much purple to make a very dark forest green. Using fairly thick paint, the hake brush and vertical strokes, paint the background solid. Be sure the entire canvas is covered. After it dries you may need to give it a second coat to get complete coverage.

3 Underpaint Water

To the dark green color from the previous step, add a fourth as much Ultramarine Blue. Use your no.10 hake brush to make long horizontal strokes that completely cover the water area. As in the previous step, you may need to give it a second coat after the first coat has dried. Add touches of white for variations in tone and value, and once again, be sure the canvas is completely covered.

4 Underpaint Middle and Foreground Snow

This is also a fairly simple step. First, mix white or gesso, half as much Ultramarine Blue, one-fourth as much Dioxazine Purple, and a small amount of Burnt Sienna. This should create a very clean mauvish gray. Now, take your no. 10 bristle brush and completely block in all of the middle ground and foreground. Make sure the canvas is well covered. Also, notice the irregular strokes along the edge of the forest and the water's edge. Keeping all the edges soft with no hard lines will make a difference later when you highlight the snow.

5 Add Form Shadows on Background Trees

Use the color from the previous step and your no. 10 bristle brush with a straight dabbing stroke to create the form of each pine tree. Notice the different shapes and sizes and interesting pockets of negative space around the trees. Now, add a little more purple and Burnt Sienna to the dark green from step 2. Take your no. 10 flat sable brush and use this color to define each trunk. Be sure these trunks create good negative space, which makes for good composition and eye flow among the trees.

6 Highlight the Snow, Phase 1

I have to admit that the painting looks a little strange at this stage, but never fear, things are going to change quickly. Mix white and just enough orange to slightly tint the white. Using your no. 6 bristle, begin dry-brushing in the contour highlights of the snow. This is where your creative juices and artistic license really need to work together. At this point, it is critical that you have excellent eye flow and negative space. Remember, this is only the first phase of highlighting; you will be adding one or two more layers later.

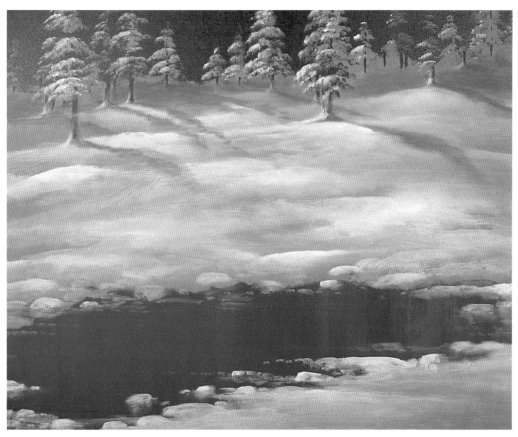

7 Highlight Pine Trees and Add Shadows on Snow

Use the tinted white from the previous step and your no. 6 bristle brush to dab a highlight on the left side of the trees. Now add purple to the snow shadow color, and drybrush in the shadows of the pine trees, being sure to follow the contour of the snow. You will want to keep these shadows very soft. Later on you can refine them and adjust their value and/or color if necessary.

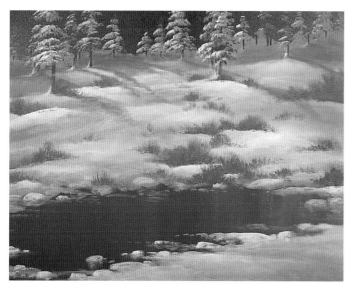

8 Block In Middle Ground Brush

This is a really fun step, but also a very important one. The greatest danger here is making the middle ground too busy. When you add the bushes, be sure you arrange them so that your eye flows gracefully throughout the canvas rather than bouncing from clump to clump. Mix Burnt Sienna with a touch of purple and a bit of white to change the value. Use your no. 6 bristle brush to apply this mixture with a vertical dry-brush stroke, feathering and lightening the pressure as you pull upward. Remember, this is only the underpainting; you will detail the bushes later.

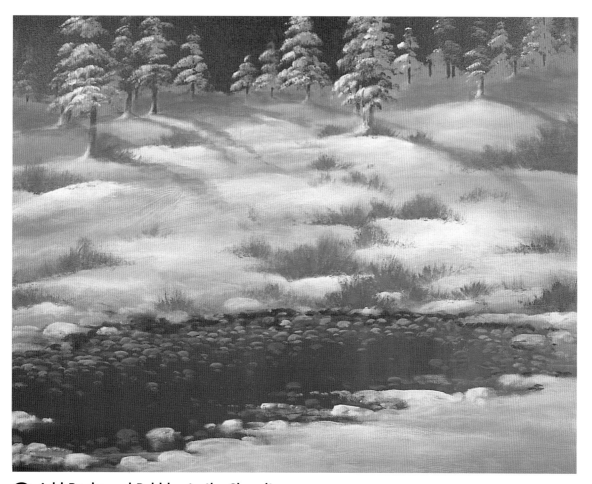

9 Add Rocks and Pebbles to the Shoreline

Here you will begin to get down to the "nuts and bolts" of the painting. I use my no. 4 flat sable brush and a variety of colors to which I've added touches of white to change the values and tones. For example, Burnt Sienna is great by itself, but when you add a touch of white, you get a nice, earthy tan. Add touches of white to all of the colors on your palette—blue, purple, red, green, Burnt Umber, etc.—to make a good variety of colors. Next, simply make small rounded shapes along the water's edge. Notice how the rocks gradually fade out toward the center of the water to create the illusion of transparent water. Now, take Hooker's Green with a touch of purple, and drybrush in a choppy, dark edge to the water.

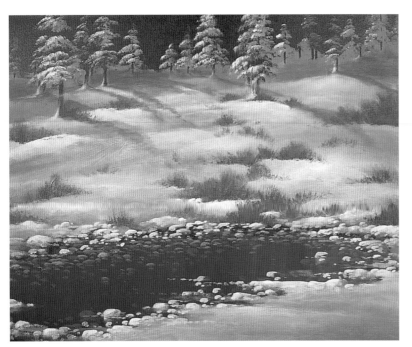

10 Add Piles of Snow Along the Shoreline

For this step, you will need to remix the snow highlight color: white with just enough orange to slightly tint it. Now, with your no. 4 flat sable brush, place small mounds of snow along the shoreline and on top of some of the rocks. Gradually work the mounds up into the middle ground and out into the water. When you start adding more details, you will add more of these mounds along with more highlights. As always, you need to pay attention to your negative space here. As long as you pay close attention to the rules of good composition, you can add as many of these snow piles as you wish.

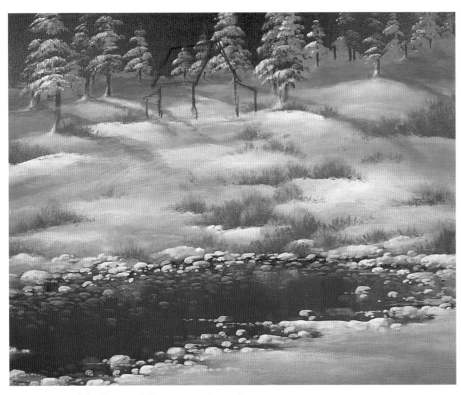

11 Highlight Middle Ground Bushes

This is the point where the color really begins to show up in the painting; however, before going any further, take your soft vine charcoal and make a rough sketch of the mountain cabin. This helps establish the proper proportions. Now, take your no. 6 bristle brush and mix Burnt Sienna with touches of red, orange and white. Begin at the top of each bush, and apply this color with a very dry downward stroke. Keep in mind that the sun is coming in from the left side. This will probably be only an intermediate highlight, so don't go overboard here.

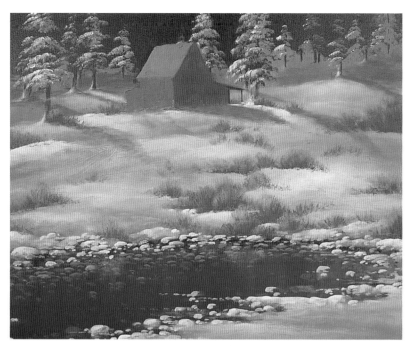

12 Block In the Cabin and Add Shadow

First, take some of the original gray that you mixed for underpainting the snow. Use your no. 6 bristle brush or your no. 4 flat sable to block in the roof with a solid coat of gray. Next add a touch of Burnt Sienna to the gray, and block in the right side of the cabin. Add a touch of white to the mixture and block in the left side of the cabin. Don't worry about the details yet, just square it up. Add to the gray a touch of purple, or a little blue if you like, and smudge in the shadow, keeping the edges soft. You will refine this shadow later; for now just be sure the shadow follows the contour of the land.

13 Detail Cabin, Phase 1

The details added to the cabin will differ depending on your own preferences, and you will wait until later to add the final details and highlights. Most of this step will be best accomplished with a no. 4 flat sable brush. Begin by painting on the roof a fairly thick coat of the orange-tinted white color for the snow highlight. Be sure to allow a little bit of the underpainting to show through. Block in the door and windows with a mixture of blue, Burnt Sienna, and purple. Next mix a highlight color of white with touches of orange and Burnt Sienna. Drybrush over the underpainting on the sides of the building to create a weathered wood effect. Add a few fence posts with a mixture of Burnt Sienna, blue, and a touch of white to create the correct value.

14 Sketch Cowboy, Horse, Cows and Tracks

Now you are ready for the exciting challenge of drawing animals and a person. With your soft vine charcoal or a soft charcoal pencil, make a simple but accurate sketch of the horse and rider, the cows, and the location of the tracks. This is an important step because you need to be sure these subjects fit properly into your composition and use of negative space.

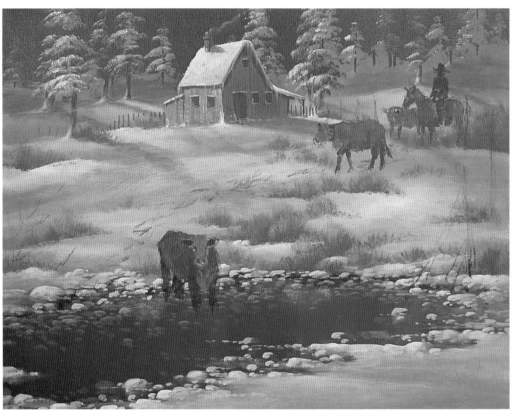

15 Underpaint Horse, Cowboy and Cows

The underpainting is the same for the horse and the cows, except that you may choose to make your horse a different color. I used a mixture of Burnt Sienna with a touch of blue and a small touch of white. Because your horse and rider are a little farther back, they should be a slightly lighter value. Your no. 4 flat and round sable work the best here. Simply block in each shape very roughly, using quick, broad strokes. Don't worry about making this perfect; you will make adjustments in the next step. You can use a dark value of whatever color you choose to paint the cowboy's pants and jacket.

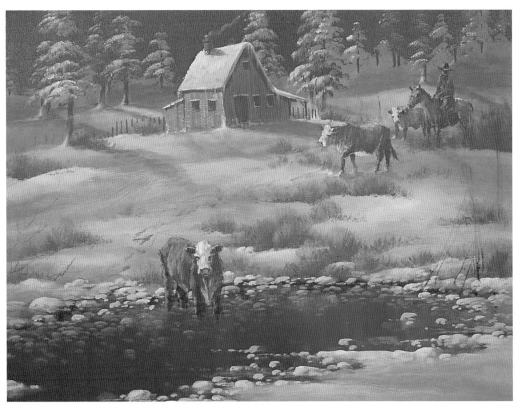

16 Add Intermediate Details to Cows, Horse and Cowboy

Here you will need your no. 4 flat and no. 4 round sable. For the cows, mix white, orange and a touch of Burnt Sienna. Apply this color using a quick dry-brush stroke that follows the contours of their bodies. You may have to do this two or three times to get the desired effect. For the heads, mix white with a touch of yellow and use the same dry-brush stroke. The important thing to remember is not to completely cover the underpainting; some of it should show through. The procedure is the same for the cowboy and the horse. Mix the proper highlight color and apply just enough to create the form. Final highlights and details will be added later.

17 Block In Miscellaneous Objects

Here, all you want to do is block in all the remaining objects, such as the fence posts and dead bushes. I used Burnt Sienna mixed with touches of blue and white. The value system of this painting does not create a great deal of depth; however, your fence posts should still be painted a lighter value as they recede into the distance. Next, thin the mixture to an ink-like consistency and use your script liner brush to paint in the small bushes that will add character to the painting.

18 Highlight and "Drift" Snow

Here is where you will really put the light in the painting. Make a creamy mixture of white with a touch of yellow and use your no. 4 flat and your no. 4 round sable brushes to begin "drifting" the snow up around the cabin, clumps of bushes, fence posts and other objects. Don't be afraid to apply the paint thickly so the color stays nice and opaque. You can see that this really adds a lot of sparkle to the painting.

19 Add Miscellaneous Details

Here you will add all of the details that will give the painting its more refined look, such as shadows, weeds, highlights and a glaze on the water. By now, you should be confident that you understand how to finish a painting. For instance, if your water is too dark, apply a white glaze. You can go on to add a wire to the fence posts and individual weeds scattered throughout the painting. Now is the time to add final highlights to the snow and cabin. Remember, the key is to stop before you overwork the painting.

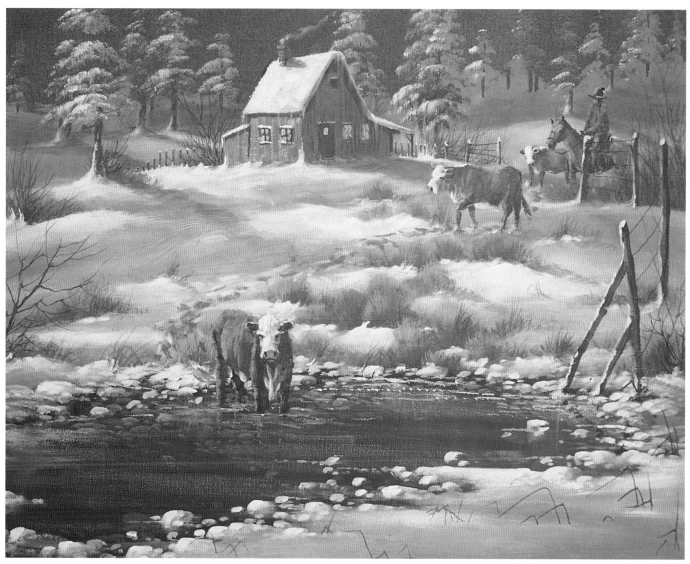

20 Add Final Details to Cows, Horse and Cowboy

What you want to do next is to clean up the forms, add brighter highlights and adjust the shapes of the cows, horse and rider. For instance, if the leg of one of the cows is too fat or crooked, or if the head is a little too large for the body, make those adjustments now. You need to have some underpainting color available for each object. There is a good chance you will need to repaint parts of the cows, horse or cowboy. If so, all you need to do is repaint using the underpaint colors and then add the highlights.

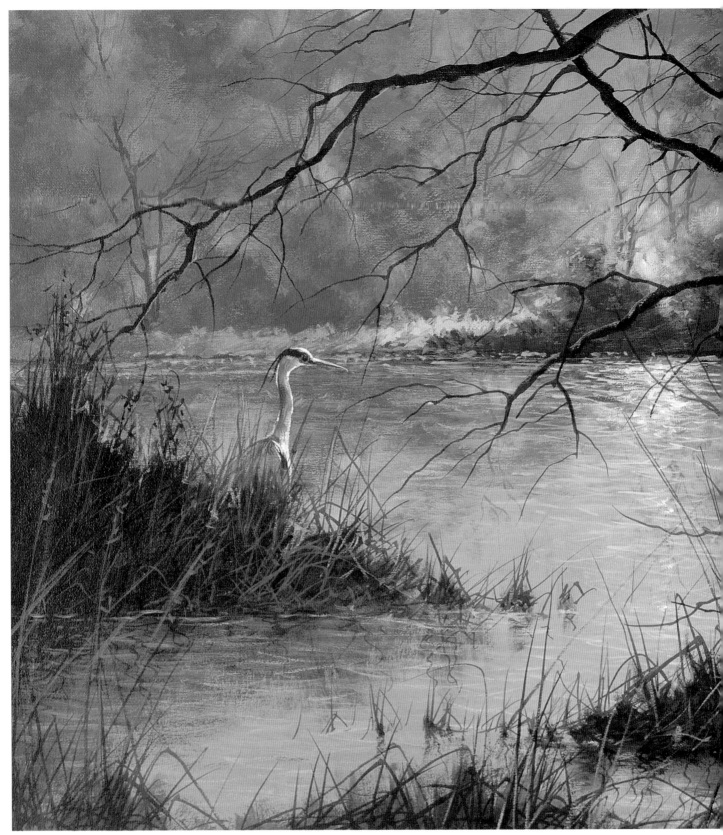

Patient Fisherman
16" × 20" (40.6cm × 50.8cm)

Patient Fisherman

Just outside my studio I have a beautiful small pond surrounded by trees, high weeds and other vegetation. It is a perfect habitat for all kinds of wildlife, especially different types of water birds. Also, the atmosphere created by the pond is wonderful with its many different lighting situations, seasons and other conditions such as fog, mist, haze, ice, etc. This little patch of ground is an artistic paradise. One early misty morning my brother photographed this blue heron that was looking for something to eat. The photo lay on my drawing table for many days until finally it got the best of me, and I had to paint it. This painting has a lot to teach about simplicity, atmosphere and the subtle use of green as the predominant color. These lessons make this painting a true artistic challenge.

1 Make Rough Sketch
First, simply take your soft vine charcoal and make the rough sketch. This is a very simple sketch of a fairly complicated painting.

2 Underpaint Background and Water
When working with this much green and this much water, it is a good idea to completely cover the background with a greenish gray color to get rid of the starkness of the white canvas. First, mix Hooker's Green, and then add one-fourth as much purple, and one-fourth as much white. Now, with your hake brush, have fun covering the background and the water area. Be sure the canvas is completely covered, and don't be afraid to let the brushstrokes show. Also, notice that the area at the shoreline is a little darker.

3 Layering Background Trees, Phase 1
The first thing to do is to gently lay in the first layers of background trees with a color that is slightly darker than the background. This is the first of several layers of trees. When you are happy with your color, take your no. 10 bristle brush and begin dabbing in the first layer using a scumble stroke. Don't worry about creating individual trees just yet. Leave a small opening just to the right of the center because you will be painting some light there later. Just be loose and free and have fun with this step.

4 Layering Background Trees, Phase 2

Next you will repeat the same technique from the previous step with a mixture that is a little darker. You will also begin to establish the basic tree shapes. Take your same mixture and add a little more green and a touch more purple, and add a little touch of Burnt Sienna to warm it up. Now, with your no. 10 or no. 6 bristle brush, begin dabbing in more individual tree and bush shapes. Remember, we are only after basic shapes, so we will not do any highlighting or anything else at this point. Also, remember that this painting will look very rough for these first few steps, so don't panic! Things will begin to change after this step.

5 Underpaint Trees in Water

Now you will move to the water. This step is identical to the two previous steps, except that as you layer the trees, you should use more of a horizontal scumbling stroke; this helps create the suggestion of ripples on the water. Begin with the color that is slightly darker than the background and gently scumble in the reflections of the background trees. Next, slightly darken the mixture and do the same thing again. Remember, keep soft edges and allow some of the background to come through. You will add light and more ripples later on.

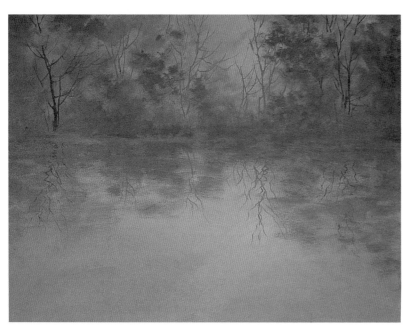

6 Block In Tree Limbs

Get ready to switch gears for a little while. Get your no. 4 round sable and your no. 4 liner brush. You may use either or both of these. Take the dark mixture from the previous step and thin it down to an ink-like consistency. Next, carefully block in the background tree limbs and the reflections in the water at the same time. Keep in mind that the reflections in the water have a little bit of a horizontal movement to them. Also, keep an eye on the negative space and variety of shapes. Don't be afraid to darken the mixture a little bit in order for the trees to show up against some of the darker areas of the background.

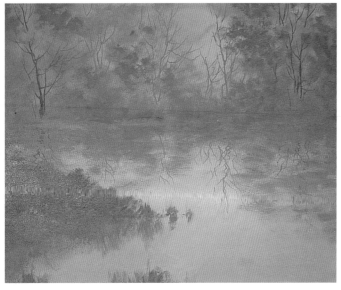

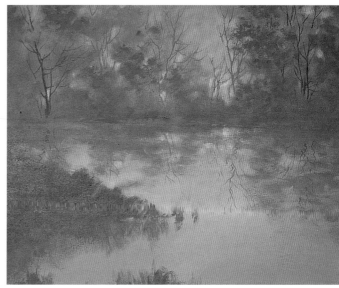

7 Underpaint Middle Ground Grass

Use the dark inky mixture from the previous step to begin underpainting some of the grasses, mostly in the middle ground. You will want to use your no. 10 or no. 6 bristle brush, and start by scrubbing with a vertical stroke the grass formations on the left side of the painting. If your mixture is too light to show up against the water, simply add a touch more green and/or purple. This is just the underpainting; you will begin highlighting in the next few steps. After you have created the grass formations, reflect that basic shape into the water, keeping the edges soft.

8 Add Light to Background and Water

Finally it's time to liven up the painting. The color you will need is a mixture of Thalo Yellow-Green, white and a touch of the grayish green that you used in the middle ground grass in step 7. Begin in the background by drybrushing in some soft pastel yellow-green then move down to the water and create the same effect. Use horizontal brushstrokes in the water, and a scumbling dry-brush stroke in the tree area. Increase the brightness by simply adding more white and yellow-green; you may need to go over this several times to get the desired effect, but it's worth the effort!

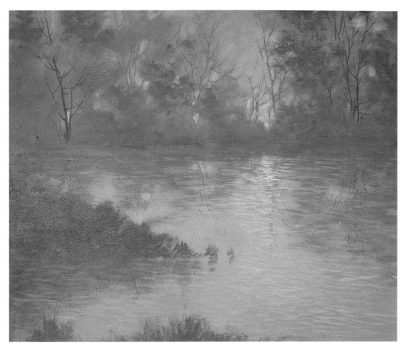

9 Add Ripples to the Water

This is a continuation of the previous step, except now, the strokes will become a bit more controlled. Using a creamy mixture of the same colors as the previous step, take your no. 4 flat sable and your no. 6 flat bristle brushes. Using short, choppy, horizontal strokes, begin applying the ripple effect to the water. I prefer to begin at the base of the painting and work up, lightening the color and pressure as I go, making sure to cover all the water. It's important to make the light much brighter up through the center of the water area. The real danger here is crowdedness, where too many strokes overlap each other. Remember the negative space rule—even in this area of a painting, all of your highlight strokes should have some connection to each other, so your eye will flow instead of bounce across the water.

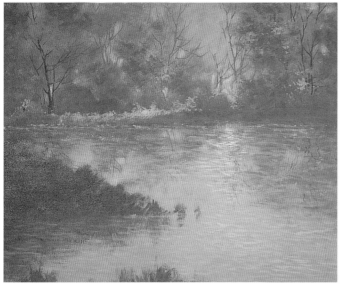

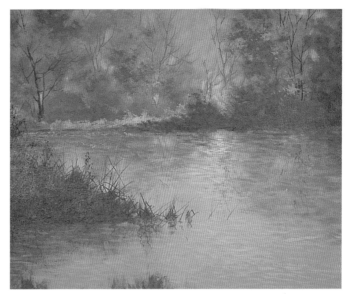

10 Highlight Background Trees

This is an exciting step. First, mix a creamy mixture of Thalo Yellow-Green, yellow and white. Now, load the very tip of your no. 6 or no. 10 bristle brush with a small amount of color and gently dab on the form highlights of the trees. You may vary the color by adding touches of Thalo Yellow-Green, yellow or white. Also, dab on highlights in the middle ground to create a glow on the grass and bushes. I know you are tired of me mentioning the negative space rule, but it is so important, especially here where you have groupings of trees. Be sure you have good eye flow and that your highlights don't end up being just a bunch of little round clumps.

11 Add Middle Ground Weeds and Darken Shoreline

This is a simple step, but a very important one. Take the dark green mixture that was used for the underpainting in step 7, and thin it to an ink-like consistency. Use your script liner brush to add plenty of tall weeds in the middle ground island that stick out on the left of the painting. Now with your no. 6 bristle brush, scrub in an irregular, darker shoreline, using a mixture of blue, a touch of purple, Burnt Sienna, and a little white to get the correct value.

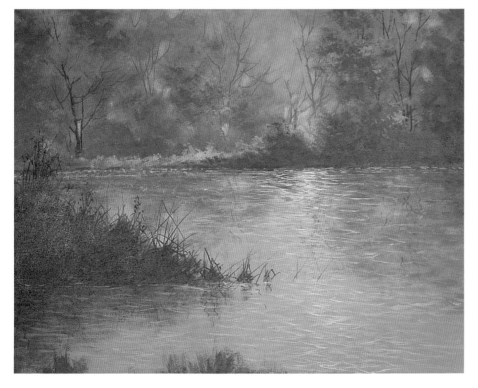

12 Add Final Highlights on Water

In this step you will be adding very thin slivers of light on top of the water to create a shimmer on the surface. First mix white with a touch of Thalo Yellow-Green and thin it so it is nice and creamy. Then with your no. 4 round sable or your script liner brush, paint thin lines along the surface of the water, using a rocking motion and following the original underpainted ripples. You can see that this really brightens the water and gives it more of a glossy look. You should also put short, choppy highlights along the shoreline.

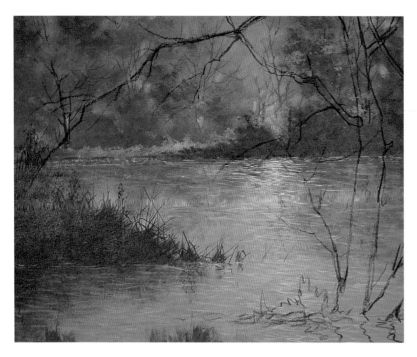

13 Sketch Large Tree in Foreground

Use your soft vine charcoal to make a simple, accurate sketch of the large tree, keeping in mind good negative space, composition and proportions. This will give you a guide when you paint so there's no guesswork.

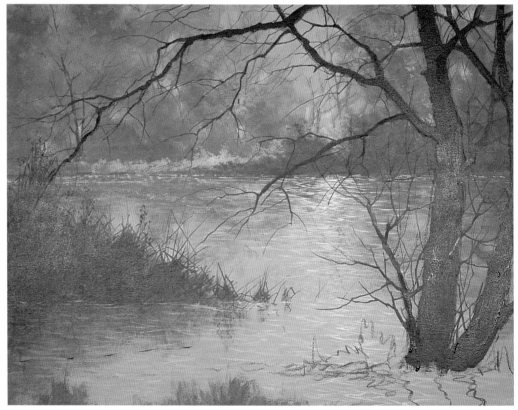

14 Block In Large Tree in Foreground

For this step, mix Hooker's Green, purple and a little bit of Burnt Sienna. Use your no. 6 flat bristle brush to block in the tree trunk and larger limbs, then switch to your no. 4 flat sable and block in the intermediate limbs. Lastly, thin the mixture to an ink-like consistency, and use your script liner to finish and taper the limbs. The main thing to remember is that your limbs should have good negative space and plenty of overlap. Also, it's not how many limbs you put in, but rather how you arrange them that can make the tree look too busy or incomplete. While you are doing this, step back occasionally because you can see the negative space problems much better from a distance.

15 Add Foreground Brush and Weeds

Next you will "plant" the tree by scrubbing up some underbrush around its base and smudging in the reflection of the tree into the water. Also add the taller weeds in the foreground and at the base of the tree. I cannot stress the use of good negative space enough at this point! Each clump of grass and all the weeds should be strategically placed to create good eye flow. There is a lot of activity in this painting with all the weeds and tree limbs, so be careful not to make too many; but don't be afraid to add as many as it takes.

16 Final Highlights

This is the tricky area of the painting that I call "accent highlights." Create a mixture of white with touches of orange and yellow. It should be a little on the orange side to complement this color scheme. I usually use my no. 4 round sable for painting these highlights. Because this is a backlit painting, you only want to use short, choppy, broken strokes to add accents just on the edges of the objects. Scatter patches of warm highlights throughout the painting.

17 Sketch In Heron

All you need here is a fairly accurate sketch of the heron, or whatever bird you choose to put here. A sharp piece of soft vine charcoal works best for this step.

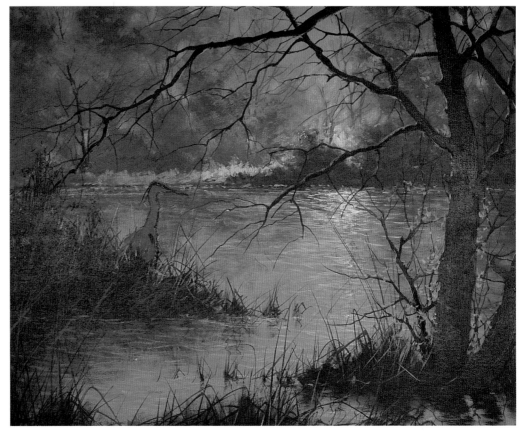

18 Underpaint Heron

Mix blue, Burnt Sienna, and touches of white and purple. Then, with your no. 4 flat sable, block in the entire bird. The no. 4 round sable may be the best choice for painting the beak. Now mix black with blue, purple and Burnt Sienna, and use your no. 4 round sable to paint in the stripe on his head, the feather hanging from his head and the little patch on his shoulder.

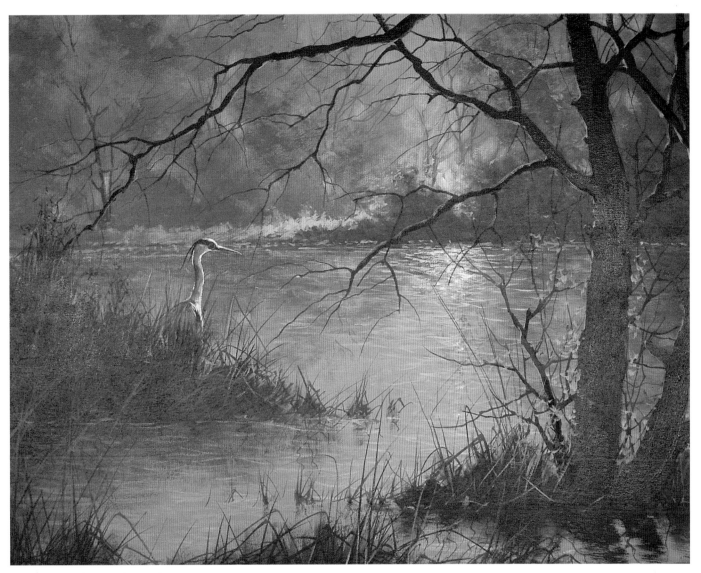

19 Add Details to the Heron

Brush in just enough highlights and details to give the heron good form. White with a touch of yellow works best for highlighting the outer edge of the bird. Make the mixture creamy, and with your no. 4 round sable, carefully drybrush the highlight on his neck, head and breast area. Use just a touch of orange for his beak. Don't get too carried away with adding details to the bird. I hope you had fun with this painting and can see it has so many possibilities!

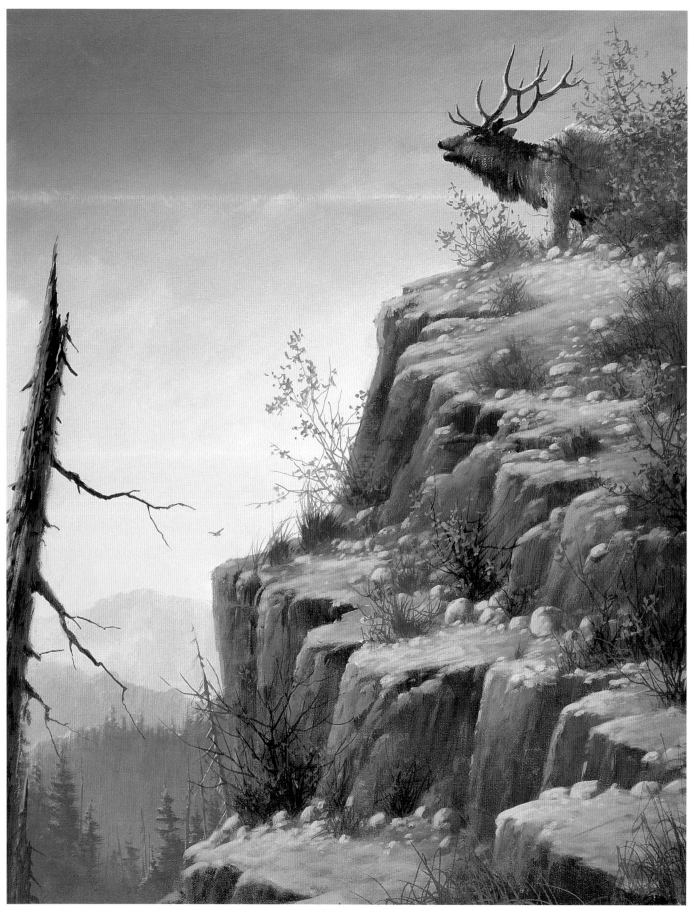

High and Mighty
20" × 16" (50.8cm × 40.6cm)

High and Mighty

I am still drawn to the high country. Every chance I get, I go to the mountains to study, research, paint and simply unwind. After living in the mountains and having a studio and gallery in Taos as well as Angel Fire, there is hardly a day that goes by that I don't recall my daily hikes into the wilderness areas of northern New Mexico to photograph and study the deer, elk and other wildlife. Along with the wildlife, there are numerous rock formations and different ground contours that can be a real inspiration as well as a challenge for most artists. As you can see, this painting offers a wide range of rock and ground formations; the different levels of cliffs create the potential to be a compositional nightmare. Be sure that you work out the design aspect of these formations before you get started. Believe me, that little extra effort will really help cut down on frustration later. This is a very satisfying painting because you will walk away feeling as if you have overcome a great challenge when you are finished. Climbing a mountain requires a very slow, careful approach—watching every step and handhold until you reach the top. The same thing applies to painting this landscape. Carefully arrange and rearrange all of the formations using all of the technical tools of composition like negative space, overlap, eyestoppers, etc. until you have completed the task.

1 Make Charcoal Sketch

Because this is an unusual composition, it's a bit more important here to make an accurate sketch of the basic configuration of the cliff and rock formations.

2 Block In the Sky

You will want a fairly clean sky for this painting, with a few soft clouds; however, since the sky is not the focus, it's best to keep it simple. First, start at the very base of the sky, and with your hake brush and a liberal amount of gesso, paint white about halfway up the sky, adding a touch of yellow and orange as you go up. This will be a very soft pastel horizon color. You don't even have to rinse your brush. Repeat the same process at the top of the sky, starting with gesso, but adding touches of blue, purple and Burnt Sienna as you blend down. When you reach the horizon color, gently blend the two colors together so that there is no hard edge.

3 Add Clouds and Distant Mountains

Use your no. 6 bristle brush with a mixture of white and a touch of orange to scrub in some very soft clouds beginning at the center and working up. This is a dry-brush stroke, so be careful to keep the clouds soft and somewhat scattered. Next, mix three values of a grayish purple mountain color using white, blue, purple and Burnt Sienna. The exact color is up to you—if you like more purple, blue or gray, that's fine; just be sure that you have a light, a middle and a darker value. Begin in the back and make each layer of mountain a bit darker. Like the sky, the mountains are not the feature in this painting, so keep them soft and simple with very little detail.

4 Block In Distant Pine Trees

This is a simple and fairly quick step, but I wanted to single it out so that you can see how important it is. You can use your no. 4 flat sable or the no. 6 bristle brush. The mixture is Hooker's Green, purple and white (your color and value may vary from mine). You'll want to make a couple of different grayish green values; use these colors to dab in some trees of different shapes and sizes. Keep in mind the ever-present challenge of creating good negative space.

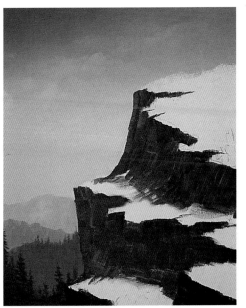

5 Underpaint Cliffs, Phase 1

This is where the painting becomes a bit more complicated, and more advanced techniques become necessary. First, use your no. 6 bristle brush for the smaller areas and your no. 10 bristle brush for the more open and larger areas. Mix Burnt Sienna, Ultramarine Blue and a touch of purple. Double- or triple-load your brush, and use short, choppy, vertical strokes to fill in all of the large open areas and small horizontal cracks on the tops of the cliffs. Notice that the canvas is completely covered, but brushstrokes are still visible where the paint varies in thickness.

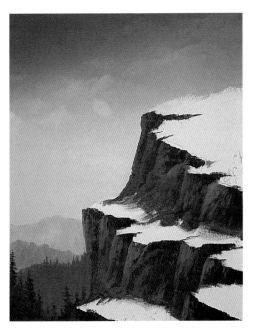

6 Underpaint Cliffs, Phase 2

This is a practical step of simply defining the edges of the cliffs, adding minor highlights and establishing the basic contour of the cliffs by adding various values of soft highlights. Good use of negative space is absolutely critical here. This is more difficult than it looks! I recommend using a no. 6 bristle and a no. 4 flat sable. Mix a combination of white, orange and a little Burnt Sienna. It's OK for the mixture to be inconsistent in color and value. Beginning on the outer edge of each section, use short, choppy vertical strokes, gradually working back into the crack of the cliff. You should be able to see a contrast between dark and light areas.

7 Underpaint Tops of Cliffs

Our main priority here is to block in the tops of the cliffs, which is important because it helps us to see the entire formation of all of the cliffs as a whole. Underpainting the tops of these cliffs requires loose, free, and somewhat rough brushstrokes. Use your no. 6 bristle and your no. 10 bristle with a mixture of white, Burnt Sienna, purple and orange. Remember, this is only the underpainting, but you still want to be sure that the entire top of the cliff is completely covered. Also notice that this underpainting has a variety of colors.

8 Add Brush and Grass

The goal here is to simply locate the clumps of brush and grasses; this helps to establish the final design of the cliffs, before you add the intermediate details. I generally use my no. 6 bristle brush for this. The mixture is Hooker's Green, Burnt Sienna, purple and white to get the right value. Play with this mixture until you are pleased with the color. Now, use a variety of brush and grass techniques which you have used in previous paintings. Add a good variety of bushes and grasses that complement your existing composition and negative space areas.

9 Finish Background

This really is a fun step; you can truly use your artistic license here, but just be careful not to overdetail or emphasize any of the background subjects. The background cannot overpower the foreground. First, dry-brush a whitish yellow mist on the left side of the painting to soften the edges of the distant mountains. Simply take a touch of white and a little bit of yellow, and with your no. 6 bristle brush, use a dry-brush circular motion and blend out the left side of the mountains into the sky. Then with your no. 4 round sable and a little Burnt Umber with a touch of white, block in the dead pine trees behind the cliffs. Next, you can go ahead and highlight the trees with a touch of orange and white, or even a little Thalo Yellow-Green, using your no. 4 flat sable brush.

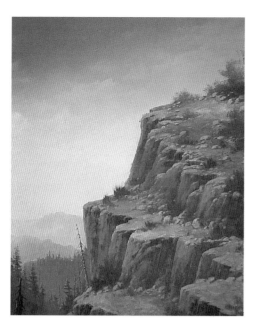

10 Highlight Rocks and Pebbles

Now we are getting down to some serious business here. Next you will add a good number of small rocks and pebbles, which is a fairly time-consuming process, so take your "patience pill" and have fun locating the best place for the rocks. Notice that most of them are located at the base of the cliffs. Once again, negative space and good composition are necessary for this to work properly. Use your no. 4 round sable with Burnt Sienna and touches of blue and white for the dark side of the rocks. Use white with a touch of orange for the highlight. Make a good variety of shapes and sizes, and be sure you have plenty of rocks touching and overlapping.

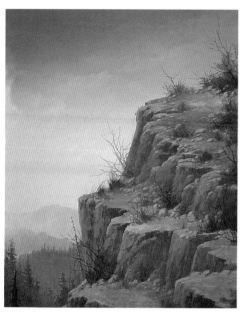

11 Add Miscellaneous Details to Tops of Cliffs

Next you will add the small twigs, branches and individual weeds, but only the most necessary ones at this point. (After you finish detailing the cliffs you will add other branches and weeds in different colors and values.) Mix Burnt Umber with plenty of water to create an ink-like mixture. Now use your script liner brush to add plenty of dead branches, twigs and individual weeds. By now you should have developed good control with your script liner brush. If you like, you can change the color and value for the weeds by simply adding a touch of green, orange, Burnt Sienna, yellow and/or white. Just experiment, have fun, but don't overdo it.

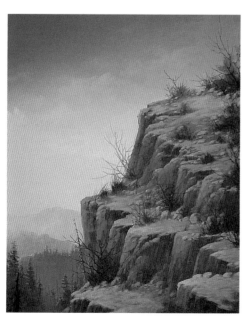

12 Add Cliff Highlights

Putting the final highlights on top of the cliffs will help establish the brightness of the painting. The main color will be a mixture of white and orange with a touch of yellow. The mixture can vary, so don't be afraid to experiment. Now, with your no. 4 flat sable or your no. 6 bristle brush, begin applying the highlights on the more sunlit areas of the cliffs. Don't overhighlight or you will lose the contrast that gives the cliffs their form. Go ahead and highlight some of the rocks as well. How bright you make this is up to you. It may take two or three layers to achieve the desired brightness.

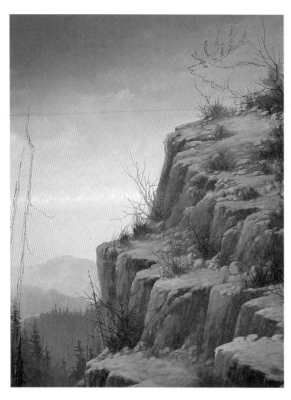

13 Sketch Elk and Dead Tree

Anytime that you add wildlife or any other subject that needs to be anatomically correct, it is important to start with a fairly good sketch. This will go a long way in helping you maintain accuracy of the proportions as you paint. Use your charcoal to sketch in the elk and the large dead tree. Don't be afraid to resketch several times; this is what is so great about using soft vine charcoal: It's so easy to remove.

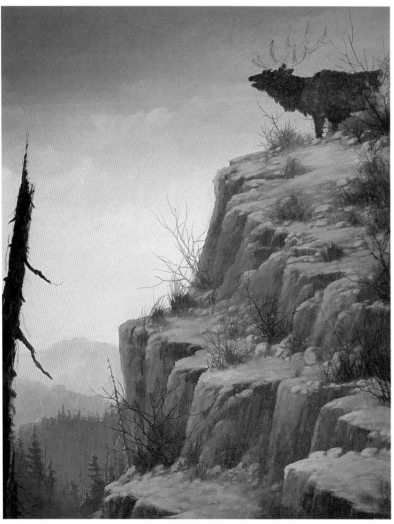

14 Underpaint Elk and Tree

Your small round and flat sable brushes will really come in handy for this step. For the front part of the elk, use Burnt Umber; for the rest of him, add just a little white to the umber and block in the rest of the body, making sure there is no hard outline around the body. Then use a mixture of blue, Burnt Sienna and purple to block in the dead tree with short choppy, vertical, strokes. On both the elk and the tree, be sure the canvas is well covered with paint.

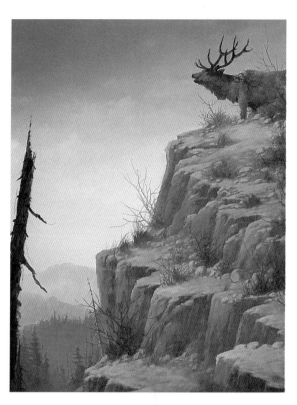

15 Detail Elk, Phase 1

This is where it will really be necessary to have patience and a good understanding of some of the dry-brush techniques. In this phase, you only want to paint the basic highlights of the elk, establish his form and block in his antlers. First, thin down some Burnt Umber and block in the antlers with your no. 4 round and flat sable. Next, with a fairly creamy mixture of Burnt Umber with touches of white and yellow, drybrush in the intermediate highlights on his back, shoulder and side. Be sure your strokes follow the contours of his body. Smudge a little bit of this color on his forehead and over his eye. That's all for now; you will finish him up a little later.

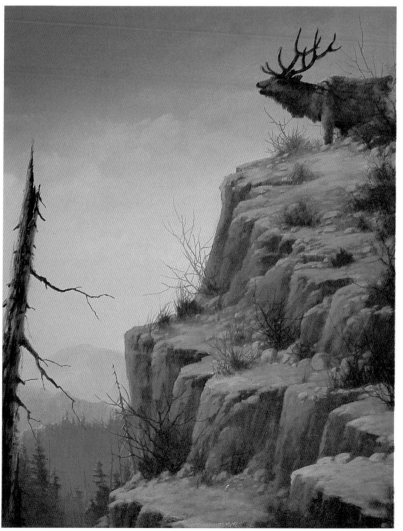

16 Detail the Tree

Since this tree is in the immediate foreground and serves as the painting's main "eye stopper," it needs to have a good deal of detail work. Notice that it has several colors on it. For the highlight on the left side, use white with a touch of orange, and even a little Burnt Sienna and yellow. I prefer to turn my no. 4 flat sable vertically and use short, choppy, vertical strokes to apply the color. Now add touches of blue, purple, white, red and Burnt Sienna to add color and texture. When you add these colors, don't blend them all together or they will turn to mud, and don't mix them on your palette. Do not completely cover the underpainting; you want some of the dark values to show through and add depth to the bark. For the reflected highlight on the shadowed side of the tree, mix white, purple and blue. Apply just enough to soften the edge of the tree.

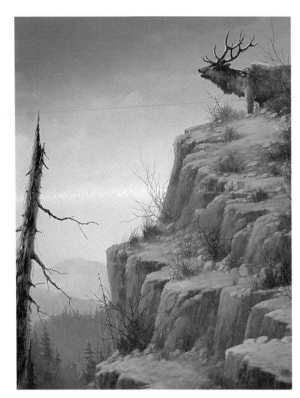

17 Final Highlights on Elk

This is a simple but very important step. First, create a creamy mixture of white with a touch of orange for the main highlights. Again, using the smaller brushes, begin adding the very bright accent highlights to the outer edges of the elk. Don't create a solid outline. Use light, feathery strokes, very much like a dry brush technique, and be sure not to put too much on your brush. You will "plant" the elk later when you pull up the bushes around his legs.

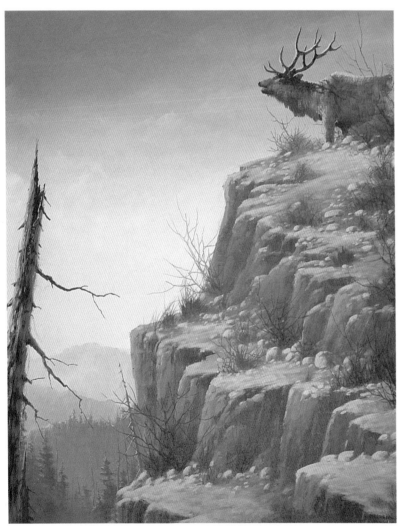

18 Add Final Highlights to Rocks and Pebbles

Now you will create intense light on a good number of rocks and pebbles. The color you will use is a creamy mixture of white with a touch of yellow and maybe a touch of orange. You want to highlight only the rocks that are the most exposed to the light; the others will be in shadowed or subdued light. With either of your small sable brushes, apply the highlights fairly thick so that they will stay opaque. Be careful not to overhighlight.

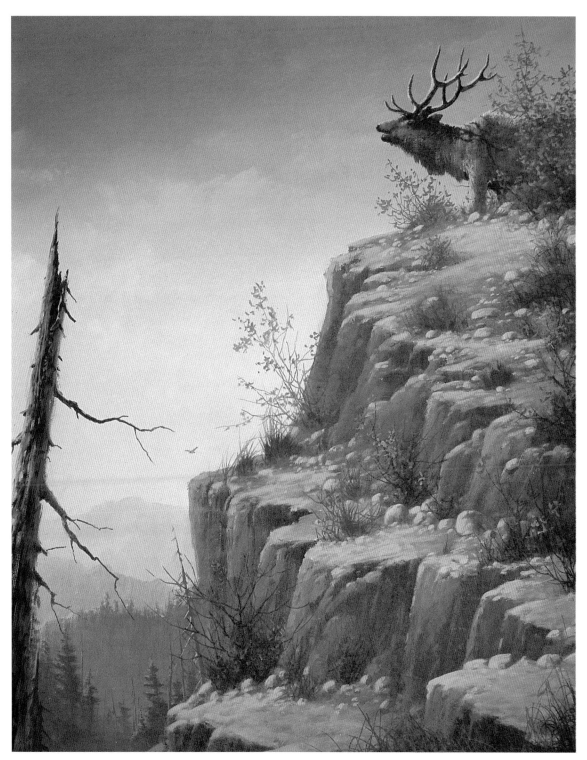

19 Finish Up

At this point, the painting is almost finished. This final step will be different for each of us. I chose to highlight the bushes, add some leaves to the branches and also a few complementary flowers. I painted a distant eagle to reinforce the theme "high and mighty." Once you have made all of your adjustments and added final highlights, you have one option left that can be used at your discretion: a glaze over the entire painting. This will only be necessary if you want to soften it or add a feeling of haze or mist. I decided not to apply the glaze this time. I hope you had fun with this painting, and that you're looking forward to the next one.

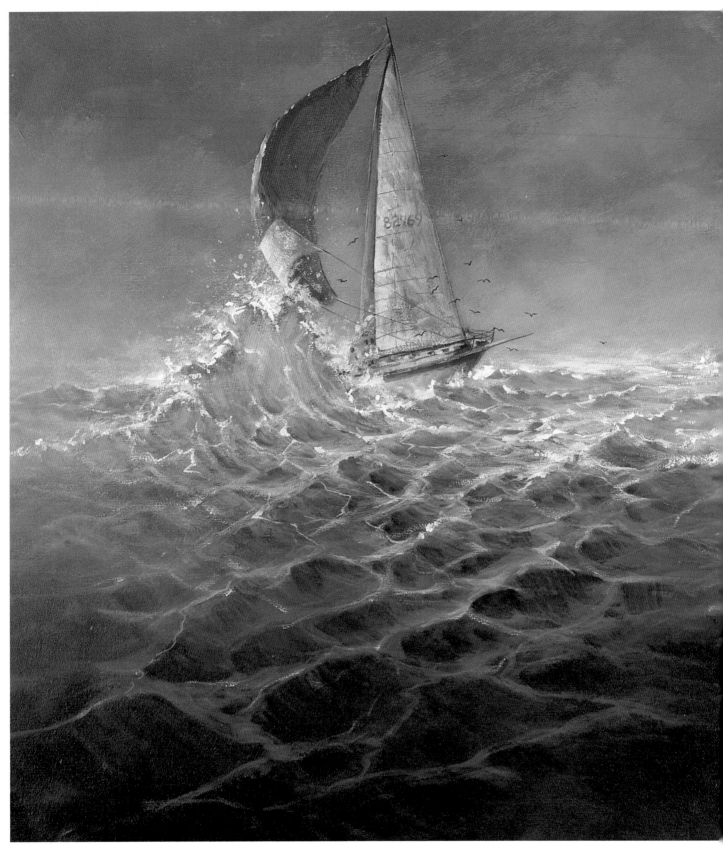

Tossed by the Waves
16" × 20" (40.6cm × 50.8cm)

Tossed by the Waves

I have never lived near the ocean nor have I spent much time there, but like so many artists, the ocean is so exciting to me that I am compelled to paint it. Every so often I have the desire to unleash that excitement onto my canvas. This painting proved to be the perfect challenge because of the focus on action, movement, composition and mood. Believe me, it is more difficult than it looks to take this large body of water and make something very interesting out of it. A good understanding negative space is especially necessary with this painting, so it may be a good idea to review the composition principles before you begin. There is a lot here to challenge you, and I think you'll find the adventure an enjoyable one.

1 Make Charcoal Sketch

How about this for a sketch: a straight line across the center of the canvas! That's all it takes to get this painting started.

2 Underpaint Sky, Phase 1

You will begin with the sky; however, instead of using the hake brush, you'll use your no. 10 bristle brush and a scumbling stroke. First, load your brush with gesso, then add small amounts of blue, purple and Burnt Sienna, and scumble or scrub small sections at a time while working your way across the canvas, making sure to keep the edges soft. Don't be afraid to use plenty of paint. Even though this goes on fairly opaquely, it will require one or two more applications to get full coverage. As you can see, this ends up as a mottled gray sky.

3 Continue Sky, Phase 2

The next step is to build the darker areas in the sky to help create a bit more of a stormy look. Create a mixture of small amounts of blue, Burnt Sienna, purple and a touch of white. This color should be slightly darker than the sky. The technique is pretty much the same as above, except that you should be a little more specific about cloud formations. Again, you will use your no. 10 bristle brush. Have fun creating some exciting, free-flowing clouds.

4 Accent Sky, Phase 3

In this step, the brush technique remains the same as before, you will only change the color and values of the sky area. The best color for this is a soft pinkish highlight of white, red and a touch of blue; this is a nice complement to the gray background. Scumble or scrub soft, light accents of contrasting values against the darker background. Once again, remember to keep soft edges and create good negative space. Don't be afraid to experiment with different combinations of complementary colors to create just the right mood and atmosphere.

5 Underpaint Water, Phase 1

Wow! You can really work out your frustrations in this step! Block in the water with large, loose strokes using your no. 10 bristle brush. In this case it is important to see the brushstrokes, and be sure the canvas is completely covered. The colors you'll need are Hooker's Green, touches of blue, purple, Burnt Sienna and even a touch of yellow now and then. Of course, you will simply add a touch of white when you want to change the value and create a more opaque coverage. Notice that there are several light and dark areas and how the brushstrokes create a dramatic sense of movement.

6 Continue Water, Phase 2

Next you will want to add some intermediate light values to the water and begin to establish a sense of distance in the painting. First, using the no. 6 bristle brush, take a little white and touches of red and blue, then scrub across the horizon, creating a soft, hazy mist. Blend this up into the sky, and then down into the water until the hard edges disappear. As you come forward, switch to the no. 10 bristle brush and add touches of green, blue and purple to the above mixture and begin creating more defined movement in the waves. Bring this color forward a little over halfway, until everything fades together in the foreground.

7 Block In Large Wave

This is a fairly simple but critically important step. The location, size, proportion and color of the large wave are the key factors here. You may want to make a rough sketch with your charcoal to locate it. Then take your no. 10 bristle brush, and use the same combinations of color that you used for the underpainting in step 5 to paint in the wave, carefully blending it into the middle ground water. You will highlight and detail this area later.

8 Highlight Water in Background

With your no. 6 bristle brush, take white with a touch of yellow, and a little blue, and begin creating some turbulence in the water behind the big wave and across the background. Make your strokes choppy and loose. This is a small area, so don't try to create a lot of detail, and keep this choppy water behind the large wave. This will serve to separate the background from the foreground. While you are at it, you may want to use your charcoal to sketch in the small island on the right side.

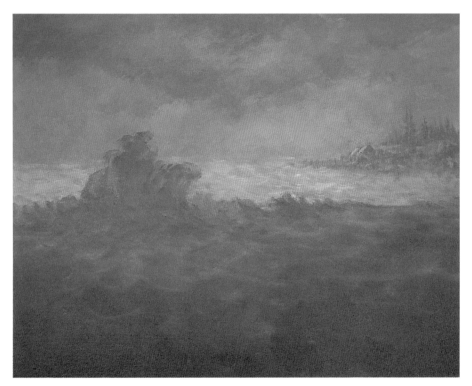

9 Underpaint Island

For this next step keep in mind that you want to create a sense of distance, so the colors for the island should be the same values as the other colors in that area. I suggest that you use your no. 4 flat sable for this. Mix white, Hooker's Green and a touch of purple and scrub in the suggestion of a rocky shore and distant trees. Next use this color with white and a touch of orange to put a soft highlight on the rocks along the base of the island. There should be only a suggestion of highlights.

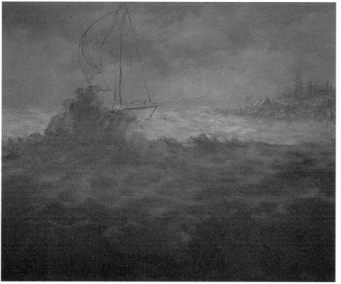

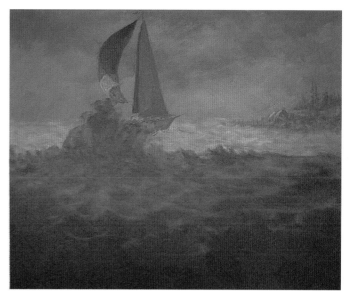

10 Sketch Sailboat

Next use your charcoal to sketch in the sailboat. It's okay to choose another type of boat as long as it fits the composition. The location of the boat depends on where you put the large wave, so if your main wave is in a slightly different location than mine, be sure to adjust the placement of your boat.

11 Underpaint the Sailboat

You will need your no. 4 flat sable brush for this step. First, mix a soft gray of blue, Burnt Sienna, a touch of purple and of course, white. Underpaint the front sails and body of the boat and the lower half of the red sail. Next, mix red with the gray, and underpaint the shadowed side of the large sail. Mix red, orange and a touch of white to paint in the sunlit part of the red sail. Use white with a touch of orange to highlight the white part.

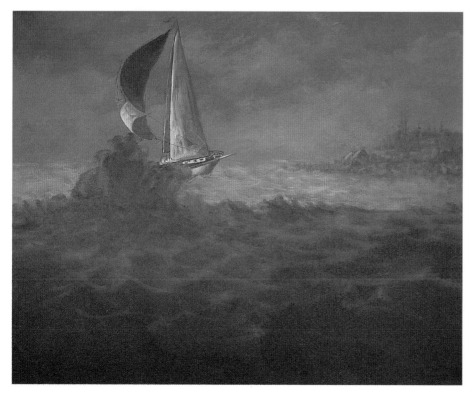

12 Detail the Boat

Here, all you need is a good imagination. You can finish the boat just about any way you like; it is important however, to complete the boat before moving on to the next step. Use your no. 4 flat and round sables and your no. 4 script liner for these details using clean and light quick strokes. Don't be afraid to use pure white and pure red to get the clean bright color that you want. Simply brighten the underpainting until you are satisfied with its intensity.

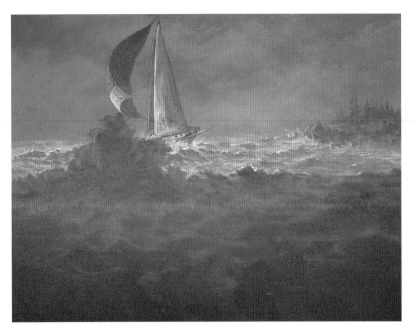

13 Detail Water in Middle and Background

In this step you will add shadows, highlights, mist and motion to the areas around the boat, over to the island, and up to the large wave. Most of this will be done with your no. 4 flat sable and your no. 6 bristle brush. A mixture of white with a touch of yellow works great for the highlight. Your dark mixture will consist of green with touches of blue, purple and white to change the value. Now all you do is intensify the shape and movement of the waves, and place the white caps along the ridges of the waves; this takes a little effort, but it's well worth it.

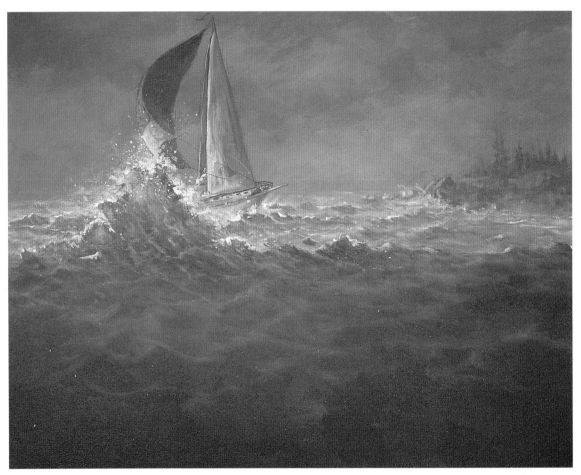

14 Detail Large Wave, Phase 1

The main thing to accomplish here is to give the wave more of a transparent look along with some minor details. For this you will use your no. 4 flat and round sables. First, take a small amount of Thalo Yellow-Green and a touch of white and carefully drybrush this color at the top of the wave where it begins to break. Next, with white and a touch of orange, dab in the white foam around the outer edge of the wave. Don't outline the wave, just define it. Thin down some white, almost to a wash, and use a toothbrush to spatter some mist around the outer edge of the wave.

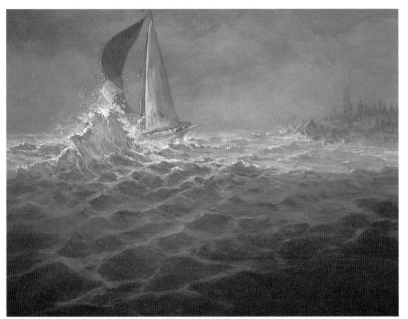

15 Detail Large Wave and Foreground
The main goal here is to continue building the wave with dark and light values, and then fade it into the foreground. The base mixture is white, blue and a touch of green; you will change this mixture as needed. Use the underpainting as a guide to darken the darks, lighten the lights and intensify the highlights on the crest of the waves. Then make the large wave look more transparent by adding a touch of Thalo Yellow-Green and a touch of white to the upper part of the wave.

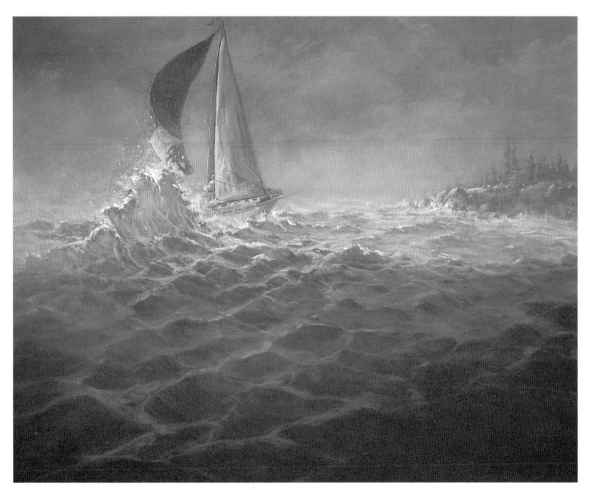

16 Add Mist to Horizon and Highlight Island
This step is an absolute must. You will drybrush in a soft horizon to lighten up the existing one, and create a little more atmosphere and depth. Start by making a wash of water with a touch of white and blue. Use your hake brush or no. 10 bristle brush to paint this wash across the horizon, let it dry and then repeat it if you want your horizon to be more faded out. Then mix a little white with a touch of orange, and use your no. 4 flat sable brush to highlight the rocks on the island.

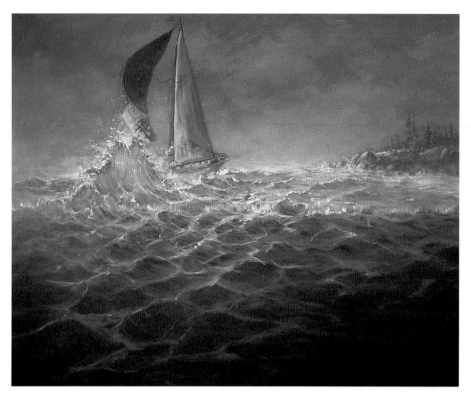

17 Add Final Highlights to Water

This is probably the most difficult step, not because there are a lot of things to do, but because it is very difficult to know when to stop. The final highlight is a mixture of white and red that's a perfect complement to the bluish gray water. You must carefully decide where to place these highlights, thinking about your composition and creating good negative space. Any of your smaller brushes will work well here, and a creamy mixture will help make the paint flow more easily.

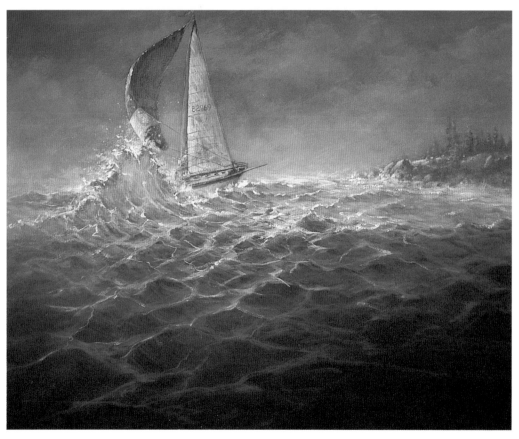

18 Finalize Sailboat Details

This step is really fun because you can just let your own artistic license take over. For me, it is a matter of highlighting and adding minor details. Some things that you might consider are: additional lines to suggest more rigging, brighter highlights, the suggestion of a person or two, additional mist or haze around the boat and maybe even a seagull or two. Just have fun, but don't make the details too crisp. The beauty of this painting is in the suggestion of details.

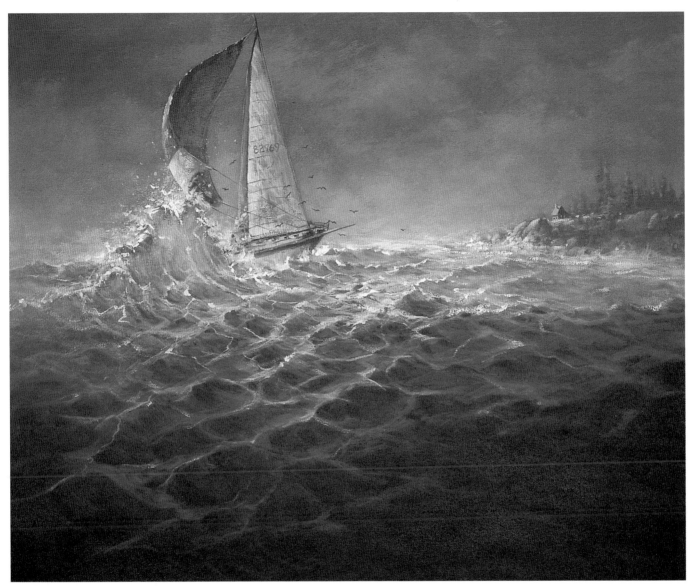

19 Refine Entire Painting

As is often the case, you may be finished by now; however, adding a few minor things such as a few seagulls, a house on the island or final highlights on the water and boat or even in the sky, may be just the ticket for giving this painting its finished look. So, as I often say, have fun, just don't overdo it. It would be a good idea at this point to stand back and study the foreground water as it moves back toward the large wave. You want to be sure the foreground negative space is not too busy. Your eye should not "get stuck" in the foreground; the composition should lead your eye gracefully and gradually back toward the large wave and the boat. If this isn't the case, you probably have a negative space problem, but don't worry, you can still adjust the values to improve the eye flow.

Misty Morning Sunrise
16" × 20" (40.6cm × 50.8cm)

Misty Morning Sunrise

What a great painting to improve your technique and stimulate your creative juices! The original painting I did of this was a 3' × 4' (91cm × 122cm) museum-type piece that took several days of study, research and painting time. Since this is a much smaller, simpler version, you will be overdoing it if you spend more than a few hours on it. This is a subject that I am very familiar with because I've spent many weekends and summers hiking near and fishing in the many beautiful rivers and streams we are so blessed with in eastern Oklahoma. As a matter of fact, the area has earned the nickname "green country." This painting will challenge even the most seasoned artist. The dense forest, running water, giant rocks and early morning mist will no doubt tickle your creative senses. This is a fairly difficult painting, but it is well worth all the creative energy you can muster up. There are a lot of great learning opportunities in this painting, so catch your breath, settle down and let's get started!

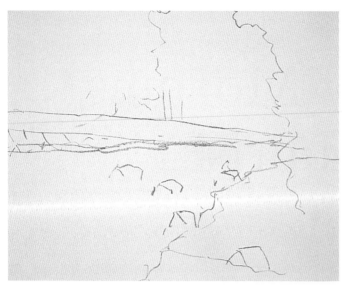

1 Create Charcoal Sketch

As usual, take your soft vine charcoal and make a rough sketch of the main areas of negative space.

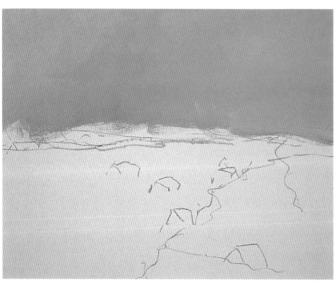

2 Underpaint the Background

Here, all you want to create is a very light, grayish white background. There are several layers of values that will go on top of this background. Mix white or gesso, a touch of yellow, purple and blue to create a soft neutral pastel color. Use your large hake brush to paint a very liberal coat of this color on the background. Let this dry completely before going on to the next step.

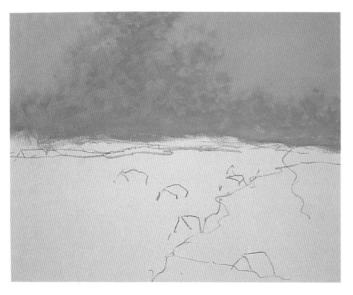

3 Underpaint Distant Trees, Value 1

You will now begin the layering process for the background trees. First, take your background color from step 2 and slightly darken it with a little more purple and a touch of green. Use your no. 10 or no. 6 bristle brush and scumble in the first layer of distant trees. Start at the bottom and go up, gradually lessening the pressure on your brush until the trees disappear. Keep your edges soft and create good negative space. Don't worry about the trees in the upper left-hand corner.

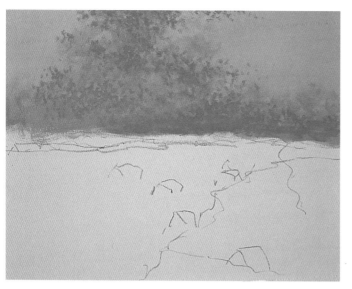

4 Paint Distant Trees, Value 2

As you probably know by now, the next step is to slightly darken the mixture by adding a little more purple and green, then use your no. 6 bristle brush to scumble in the next layer of distant trees. With each value change, you should become increasingly more aware of the forms of the trees, paying special attention to the negative space. Be careful that the tree area does not become too busy. Also, notice that the leaves go completely off the top of the canvas.

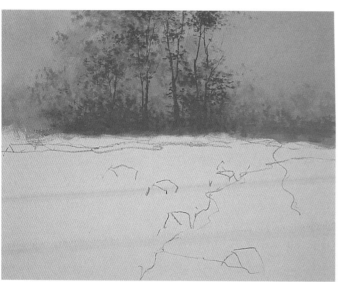

5 Paint Distant Trees, Value 3

As you've anticipated, darken the mixture and scumble in the next layer of distant trees; this is the layer where you will paint the darker foreground trees. Also, you will add the first hint of tree trunks here. Take a small dab of this darker mixture, thin it slightly, then use your no. 4 round sable to carefully paint in the first layer of tree trunks. Next, go back to your no. 6 bristle to scumble in this layer of tree leaves. This time you can be a little more specific about their forms. Notice that you can see all three values; this creates a sense of depth. If you have overpainted too much of the background, you may need to dab in a few areas of value 1 or value 2 to open up some pockets of negative space.

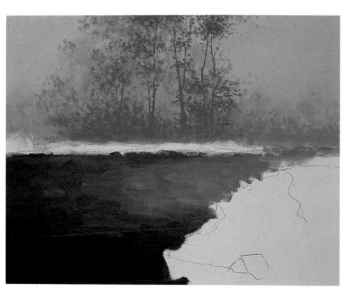

6 Underpaint Water

This is a quick and easy step. Notice that the brushstrokes are mostly horizontal and the canvas is well covered with paint. Do not premix the color on your palette; you want different values and tones. The best way to do this is to put a little of each color on your no. 10 bristle brush and simply blend on the canvas as you go; this will leave a good variety of values and tones. Use blue, purple, green and a little white. Notice how the darker area on the far left gradually fades into a lighter value toward the right side. It's okay for your brushstrokes to show here.

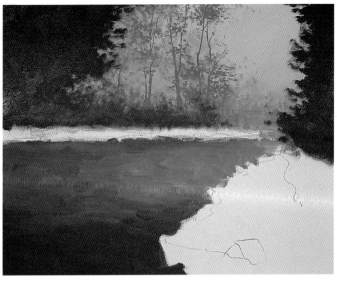

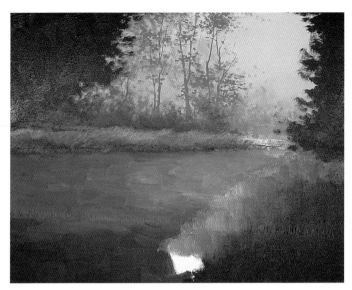

7 Block In Close-up Trees

You will need to mix a large amount of dark green on your palette that will be used for this step and subsequent steps as well. First mix equal amounts of Hooker's Green and purple, making it fairly creamy. If you want your color to be a little warmer, add some Burnt Sienna or Cadmium Red Light. Use your no. 10 bristle brush to paint in the large dark areas. Begin to soften your edges as you get toward the center of the painting; you should create some very irregular rough edges. You will come back later with a smaller brush to add the individual leaves to complete these larger trees. Also notice that I lightened a little bit of the dark color and scrubbed in some underbrush at the base of the background.

8 Underpaint Grasses

All you need here is simply a good but rough grassy effect. Mix a little Hooker's Green, a touch of Burnt Sienna and purple with your no. 10 bristle brush, and with a vertical scrub- like stroke, block in the dark areas of the grass. Then add Thalo Yellow-Green to the mixture and scrub in the lighter areas of the grass. You can add a little white to the mixture for the grass in the background, just be sure that the canvas is completely covered.

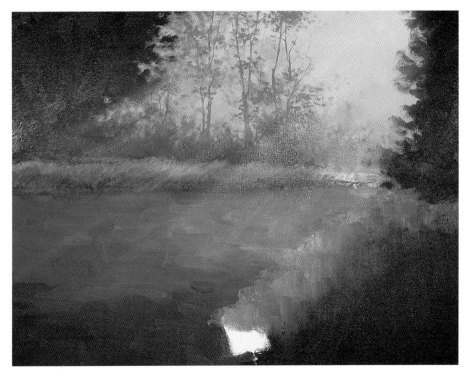

9 Add Sunrays, Phase 1

This is the first step in creating the atmosphere of the scene. This is not difficult, but you must have a very light touch and use very little paint. First, mix a creamy mixture of white with a touch of yellow. Then with a very clean and dry no. 10 bristle brush, begin in the upper right corner, apply a small amount of the mixture and begin to drag downward toward the lower left corner until you have created some very strong rays of light. You will touch them up later. You may have to repeat this step several times in order for the rays to show up.

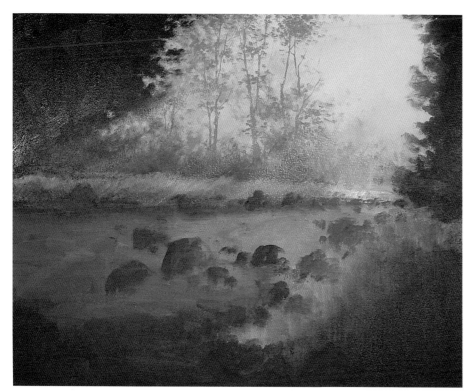

10 Underpaint the Rocks

This step is one of my favorites. Use a combination of Burnt Sienna, blue, purple and touches of white to block in all the rock formations with your no. 6 bristle brush. If it helps, sketch in the main or larger rock formations with your charcoal. Keep in mind that these rocks are a major part of the overall composition, so careful placement is critical. You want to create good eye flow with these rocks. Notice how they overlap and touch each other.

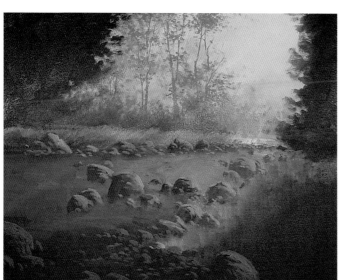

11 Highlight Rocks, Phase 1

This is a familiar step by now. Mix your highlight color using white with touches of orange and yellow, or you could use a touch of red, just as long as it is a soft, warm highlight. Slightly gray this color by adding a little blue, or even a touch of the color from step 10. Remember, this is only the basic form highlight; the brighter highlights will be added later. Use your no. 4 flat sable for this step and be sure to use quick strokes, being careful not to overwork the rocks.

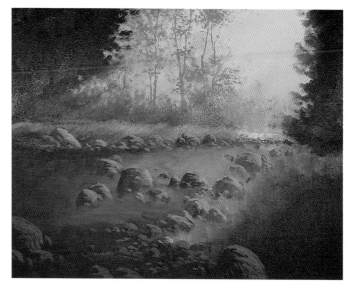

12 Add Dark Reflections in the Water

This is a very quick and simple step. Take the dark green tree mixture from step 7 and add a little more green to it. Use your no. 6 bristle brush to dry-brush in the dark reflections in the water on the left side of the painting. This area will be the "eyestopper" for the left side. Even though this color needs to be very dark, you want to gradually blend it across to the center of the water, making sure there are no hard edges. You can use a variety of dry-brush scumbling strokes to achieve this.

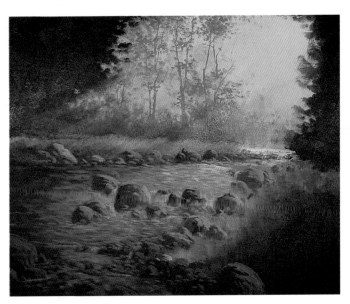

13 Add Ripples on the Water

Now this is where you will start to make some major changes. Mix white with a touch of blue; this should be a very light bluish white color and very creamy. Use your no. 4 flat and round sable brushes to create the ripples; this undoubtedly takes some skill. You want to create movement and at the same time add highlight to the water. The best advice I can give here is not to completely cover up the underpainting. The water is lighter or whiter where it is running and darker where it is calm. Use good judgment, and experiment a little bit. If you overhighlight, just add a few dark areas to open up the negative space again.

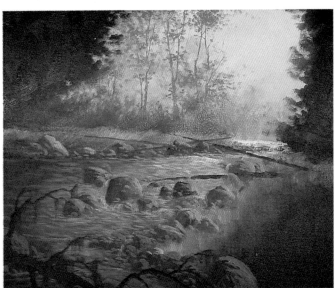

14 Block In Fallen Log and Limbs

For this step, mix Burnt Sienna, blue and purple. Sketch the objects in with your charcoal, and then with your no. 4 flat sable brush, block in the fallen log across the water and the large dead limb in front. Once again, use good judgment in regards to composition and negative space. Don't be afraid to add other limbs or logs as you see fit; they can really add interest to the painting. Adding the moss on the foreground limbs adds a wonderful creative touch.

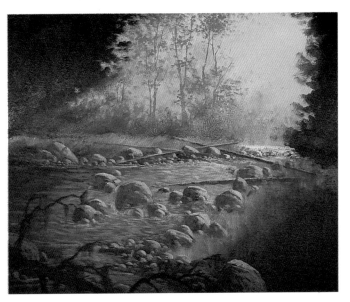

15 Highlight Rocks, Phase 2

Now it's time to begin adding the intense light that gives the painting its name. First, mix white with a touch of orange, then mix white with a touch of yellow. Use both of these mixtures to highlight the rocks. I prefer to use my no. 4 round and flat sable for this. The key here is to only accent the rocks; don't completely paint over the underpainting or the form highlight. You may have to go back to the shadowed side of the rocks and repaint certain parts of them. Since these are river rocks, their edges are slightly more rounded. You will add final details in the final stage of the painting.

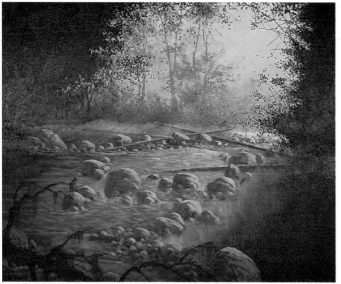

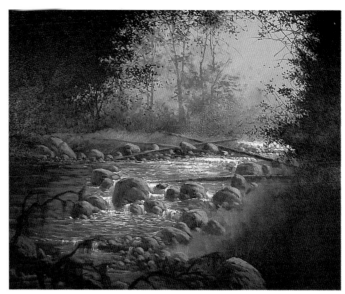

16 **Paint Leaves on Large Trees**
This is really not a very difficult step, but it is extremely time-consuming. First take the dark green mixture from step 7 and add just enough white to make it one or two shades lighter than the dark background, and add enough water to make it nice and creamy. You will need only your no. 4 round sable for this step. You will be creating a canopy of leaves over the center of the painting by using a series of overlapping scumbling strokes. Control your brushstrokes carefully to create good negative space. Begin inside the dark area and gradually work your way out. You want to have a good variety of leaves, including clumps, scattered patches and individual leaves. Finally, thin down the same color for use with your script liner brush, and paint the twigs and branches that connect the leaves together. You only want to create the suggestion of individual leaves, so be careful not to overdo the details.

17 **Highlight the Water**
This step takes some courage; in order for this painting to do what it is designed to do, you have to apply this paint very thickly and only accent the areas where the water is in motion. Use your no. 4 round sable brush, and mix a nice, rich creamy mixture of white paint (not gesso) and a very tiny touch of yellow. Apply this mixture around the edges of the rocks where the sunlight falls over the rocks, and highlight the places where the sunlight may fall on the ripples of water. When I say apply the paint thickly, I mean very, very thickly; do not smooth or blend it, simply put it on and leave it. This is the only way it will stay clean and bright.

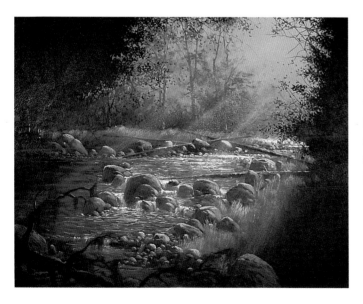

18 **Drybrush Final Sunrays and Highlights**
Simply repeat step 10; however, this time, be very specific about the location, angle and intensity of the rays. Once the rays are in place, highlight the individual objects where the rays fall, such as the tops of the rocks, pebbles, ripples and grass. Highlight with the appropriate color, white with either yellow or orange; and don't be afraid to make the light extremely bright by applying the paint thickly.

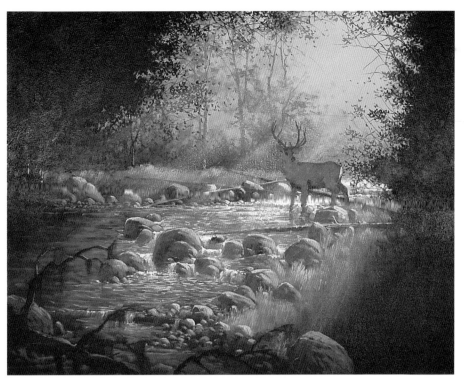

19 Underpaint Deer

First sketch in the deer with your charcoal, then mix a medium gray of white, blue and Burnt Sienna. The value of this color is established by where you place the deer. Use your own judgment; it will be different with each painting. Now simply block him in with your no. 4 flat and round sable brushes, keeping the edges soft. Also, be sure that the size of the deer is appropriate for its location.

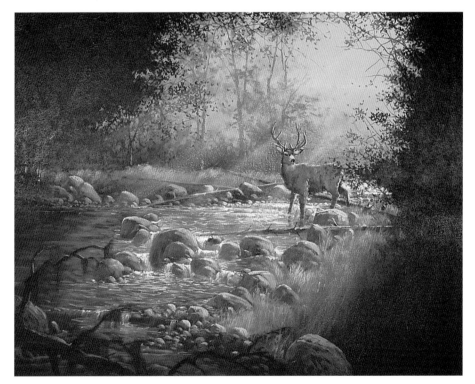

20 Detail Deer and Miscellaneous Objects

All you need to do to finish the deer is to give him somewhat of a silver lining and a minor suggestion of detail. Then you will do the same thing with the other objects in the painting, especially the logs, tree trunks and individual weeds. For the deer, you want to add a little bit of color such as Burnt Sienna, then drybrush in some shadows and add some bright accent highlights along his back, legs and antlers. Be sure that the final overall value of the deer fits the location in your painting. Then add reflected light to the rocks, and any other grasses or tree limbs that you feel would complement your painting.

21 Refine the Painting

This is the step where you make all of the necessary changes to fit your particular composition, color scheme and atmosphere; for instance, notice that I rearranged the left immediate foreground. The large limb that was there was too overpowering, so I took it out and replaced it with smaller limbs, added a few more rocks, and then I put a bluish white glaze over the entire painting to help soften it up a bit. If you decide to glaze your painting, be sure to use a very thin wash, and repeat it two or more times if necessary. Good luck; I hope you enjoyed this painting!

The Stone Wall
20" × 16" (50.8cm × 40.6cm)

The Stone Wall

Often our best subjects for paintings can come from vivid and pleasant childhood memories. Not far from my house was a park called Woodward. I recall that it had acres of beautiful trees, walking trails, babbling brooks, ponds and giant rock formations. In the springtime, endless rows of beautifully vivid pink, white and red azaleas would bloom. This was not only a marvelous playground with endless hiding places, but this place continues to influence me and my art career. Several times a year, I go back and study the beautiful surroundings; in fact, if you watch my television show, you will recognize this setting as the subject for some of my paintings. The stone wall was a special place where I used to sit and study and think. The stone stairway, the wall with the dark green foliage and the beautiful pink dogwood is an insatiable challenge for any artist. You may want to take it a step further, and add some wildlife or even some people. No matter how you choose to finish this painting, it is a great study in foliage. I know you will enjoy this one!

1 Make Charcoal Sketch

Make a simple sketch of the basic components of the painting. Once again, a detailed sketch is not necessary; however, a rough idea of the overall composition is very helpful.

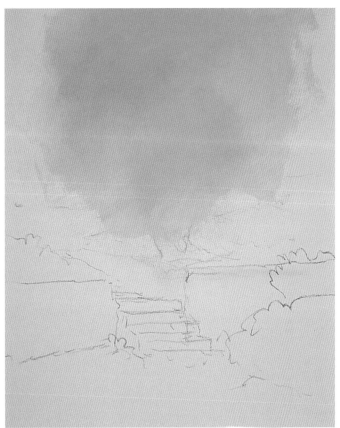

2 Underpaint Background

This first step is quite simple, but very necessary. With your hake brush, block in the center area with a soft grayish tone. The best mixture for this is white with touches of yellow, blue and purple. This underpainting needs to be fairly opaque, so be sure that you put the paint on thick and feather the edges into the background.

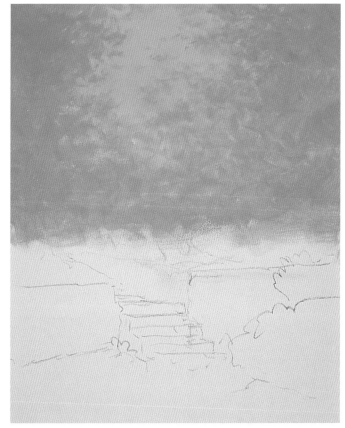

3 Underpaint First Layer of Background Trees

Now you will begin creating a sense of depth in this painting by scumbling in a very soft layer of trees. The value is slightly darker than the background, and the color is white with touches of purple, green and blue. Make the mixture creamy, then use your no. 10 bristle brush and a haphazard scumbling stroke to block in the first layer of trees. Notice that the edges are very soft and loose.

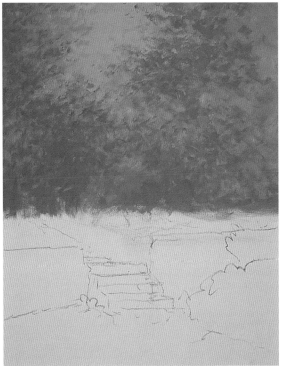

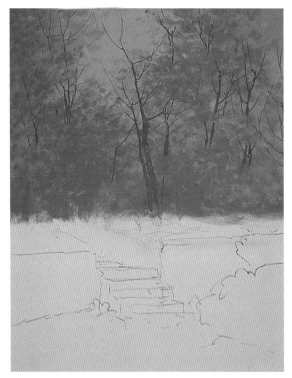

4 **Add Second Layer of Background Trees**
This step is identical to step 3, except that the value is darker, and the color is more of a grayish green. Start with the color you used in the previous step and simply darken it with touches of green and purple. Make sure the value fits your painting. Use your no. 10 bristle brush to begin scumbling in a few specific dark tree shapes. Notice the difference in values between the two layers.

5 **Add Distant Trunks and Limbs**
Take the grayish green you used for the last step and darken it slightly with a little blue and Burnt Sienna. Thin it a bit, and use your script liner brush or your no. 4 round sable to paint in all of the distant limbs and tree trunks. You'll be adding leaves to some of these trees later. Keep in mind that their sizes and forms must be in direct proportion to their locations.

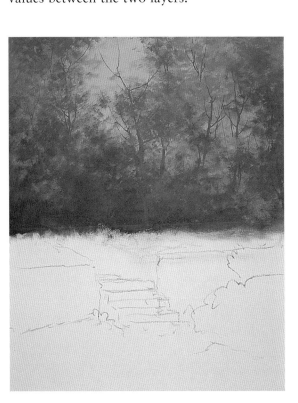

6 **Add Underbrush at Base of Trees**
Now create a mixture of Hooker's Green with touches of purple and white. Use your no. 6 bristle brush to begin scrubbing underbrush at the base of the trees. As you can see, I have taken this color on up to create more specific trees. As always, create good negative space and keep your edges soft.

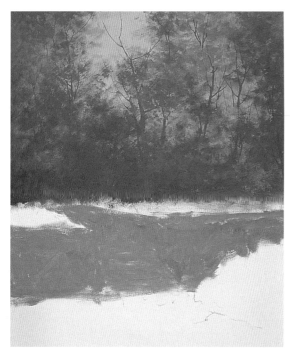

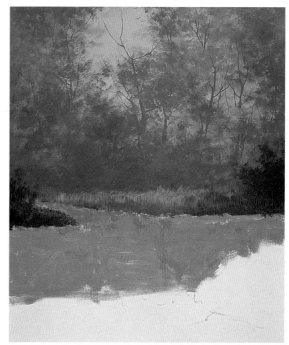

7 Underpaint Stone Wall and Steps

All you need to do here is mix a rich brownish gray of white, blue, Burnt Sienna and a touch of purple. Now use your no. 6 bristle brush to underpaint the entire wall and steps. Don't worry about any form shadows or highlights yet. This is a very loose and quick underpainting, so don't worry about exact shapes and forms.

8 Block In Middle Ground Grass

This is a fun step. You're going to create the first sign of good strong light and shadow using your no. 6 or no. 10 bristle brush. Mix Thalo Yellow-Green with a touch of yellow, and beginning at the base of the trees, lay in the sunlit grass with a vertical scrubbing stroke. Next, move down toward the wall and darken the grass with a mixture of Hooker's Green and purple. Gently scrub the two values together, and then stop when you get to the wall where it is darker.

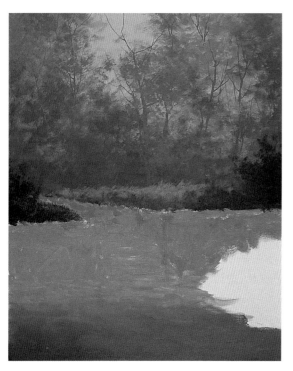

9 Underpaint Foreground

Now, with your no. 6 bristle brush, mix together white, Burnt Sienna and purple; but don't mix the colors completely together. Scrub this color on the foreground making it a little lighter at the base of the wall, and darker as you come forward. Keep your strokes very loose and choppy to suggest dirt. Be sure that the canvas is very well covered. Notice that the purple tone is the predominant color; you want to be sure the purple is very noticeable, but not overwhelming.

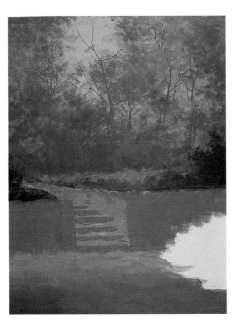

10 Add Form Shadow on Wall

All you will do here is create the basic form of the wall and steps; you will work on the stones, highlights and details later. If you haven't mastered good enough brush control to proceed without a sketch, then don't hesitate to get your charcoal and make a rough outline of the steps and wall. Use your no. 6 bristle brush to scrub in the shadowed side of the wall. Now, mix white, purple, Burnt Sienna and a touch of blue. This color should be about two shades darker than the existing wall color. You may want to switch to your no. 4 flat sable brush for the steps. Use quick and loose brushstrokes.

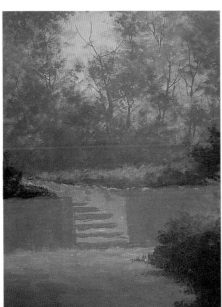

11 Underpaint Foreground Bush

This step is similar to what you did above the wall. Make a mixture of Thalo Yellow-Green and a touch of yellow, and then use your no. 6 bristle brush to begin scumbling the small bush. Darken the mixture as you come forward with more Hooker's Green and purple, and even a touch of Burnt Sienna. This bush is more defined, so give it a fairly good shape; you will refine, detail and highlight it later.

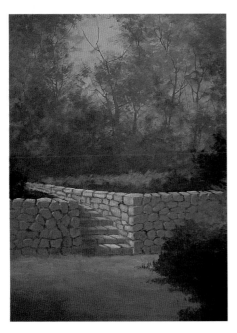

12 Put Stones on Wall

Get ready for a ride on this step because it can be fairly time-consuming and frustrating. To paint the stones in the wall, you will be creating three values of the stone color: a light, a middle and a dark. First mix a basic soft gray tone of white, blue and Burnt Sienna. For the highlight side of the stones, add more white with a touch of yellow or orange. For the shadowed side, add just a little white, plus whatever color you would like to use to darken it, such as red, green, blue or Burnt Sienna. Use your no. 4 flat sable to paint the stones. Once the stones are in place, mix a darker color for the cracks between the rocks. Then go back and make minor adjustments in form, color, shadow or highlight; as usual, you will accent them later. Don't be afraid to experiment, and be careful not to fall into a pattern of making each rock the same and lining them all up in a perfect row.

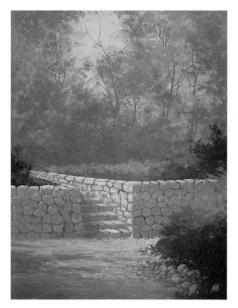

13 Detail the Foreground

This is a fun step, especially after painting all those stones. In this step you will add highlights, pebbles, rocks and shadows. The main colors for the highlights are white and orange; your no. 4 flat sable brush works best for this. Use very short, choppy, horizontal strokes for the dirt areas, then use small dabs to create a series of overlapping rocks and pebbles. After you have most of the highlights, pebbles and rocks in place, darken the mixture substantially with Burnt Sienna and purple and use your no. 6 bristle brush to drybrush some shadows on the lower left side of the painting. These shadows are being cast by some objects outside the canvas, and their main purpose is to act as "eyestoppers"; keep their edges soft and their shapes irregular.

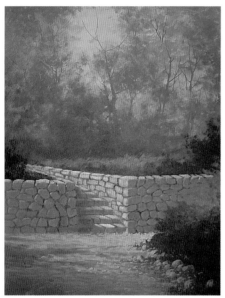

14 Add Sunlight in Background

This is a very simple but important step. We want to add a soft burst of sunlight coming through the background trees; this will help soften and add a little drama to the background. Simply take some white and a touch of yellow and thin it down some, then with your no. 6 bristle brush, drybrush or scrub in the soft light, gently blending over the edges of the trees. It may not appear that much is happening here; this is an intentional effort to create a subtle light. You may need to repeat this step to achieve the desired effect.

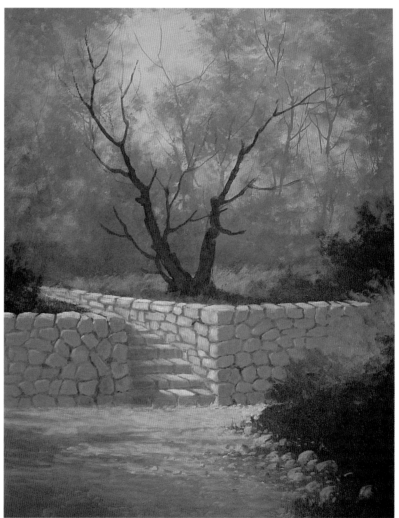

15 Block In Large Tree Trunk

This large tree is the main focus of the painting, so you should first sketch in the main shape of the tree with your charcoal. Mix Burnt Sienna, blue, a touch of purple and maybe a touch of white to change the value. Block in the trunk with your no. 4 flat sable; don't worry about the smaller limbs, you will add them after you leaf the tree. Be sure to double-check the location, proportion and negative space before you continue.

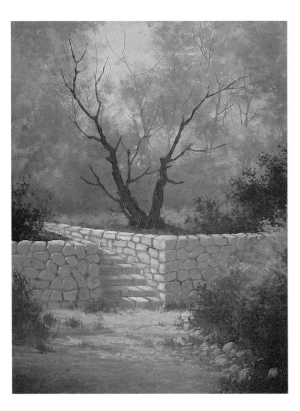

16 Finish the Bushes

This is a practice step of detailing the bushes. Start by mixing two or three values of highlight color. Those colors will vary depending on the effect you want. I mixed Thalo Yellow-Green with yellow and white, Thalo Yellow-Green plus orange, and yellow plus a touch of Thalo Yellow-Green. Keep some of a dark mixture available (Hooker's Green and purple). Now, with your no. 4 round sable brush, begin scumbling in the highlighted leaves on the bushes in the middle and foreground. You may also need to add some darker leaves.

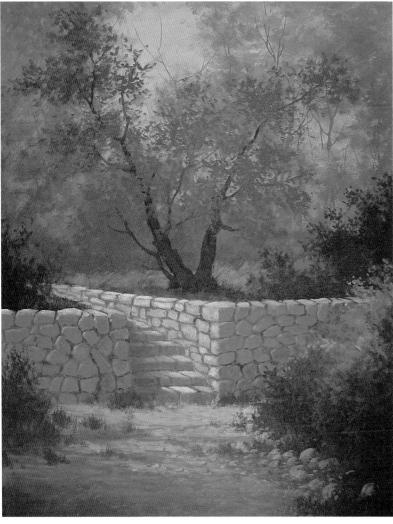

17 Leaf Tree, Phase One

This is where you will create the "heart and soul" of the painting. Mix Alizarine Crimson, a touch of red and a small dab of purple, and use your no. 4 flat sable brush to scumble in the basic shape of the leaf pattern. The most important thing to be mindful of is—you guessed it—negative space, and since this is the underpainting, it's very important to soften the edges of the leaves. This is a good time to stop, stand back and make sure that you are pleased with the composition of each part of the tree.

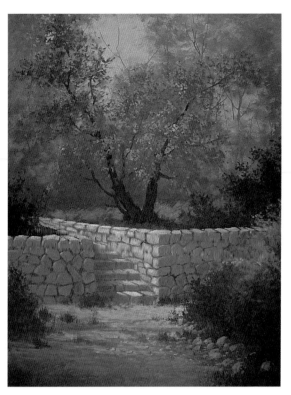

18 Leaf Tree, Phase Two

There is very little difference between this step and step no. 17. Take the underpainting mixture and add quite a bit of white. Make a second mixture of white with a touch of Alizarine Crimson. You will use these two very light highlight colors for accents. Use your no. 4 round or flat sable brush to begin scumbling in the highlights on the outer edges of each clump of leaves. A few individual comma strokes to suggest individual leaves here and there will add a nice touch. Have fun with this step, but don't overhighlight. Remember, a thicker application of paint will make the highlight brighter.

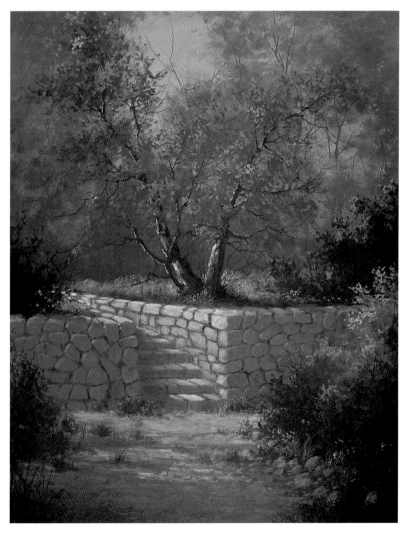

19 Add Miscellaneous Details

In this step you will add all the miscellaneous details such as small limbs, leaves, flowers, more highlights and grasses. There's quite a bit of room for creativity here; however, I am always ready to stand in favor of simplicity. All you really need to do here is mix a couple of highlight colors such as orange and white, yellow and white, or even Thalo Yellow-Green and white; then use any of your smaller round sable brushes to add the details you feel the best about. Have fun, but don't overdo it. Also, be sure to use a short, choppy, vertical stroke with a mixture of orange and white to suggest bark on the tree.

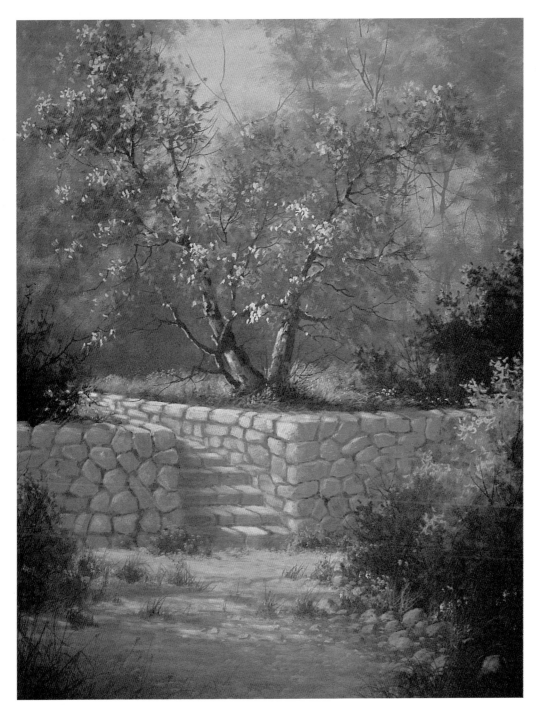

20 Refine the Painting

Once again, you have reached the point where you need to decide if you're finished with the painting. If you are completely satisfied at this point, you are ready to lay down your brushes; however, I decided to work on two more areas. First, I brightened up the highlights of the leaves on the large tree, and then I roughed up my stones a little more. At that point, I felt the painting was finished. This was a wonderful painting experience for me, and I truly hope that you have learned a lot!

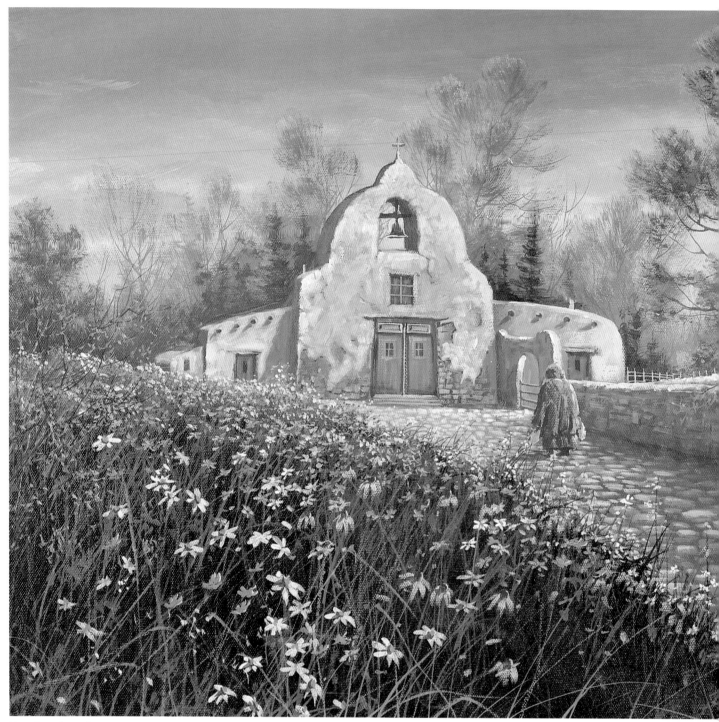

Home from the Market
16" x 20" (40.6cm x 50.8cm)

Home from the Market

Once again, familiar subjects and memories of my days in the Southwest were the main inspiration for this painting. No matter how hard I try, there are just some subjects that I can't get out of my mind until I have put them on canvas; this is one of those subjects. You may have had a similar experience with your favorite subjects. I spent endless hours studying and painting these beautiful old buildings, which are like an oasis in this sometimes harsh environment. The rugged beauty of the soft, earthy tones and textures of the adobe walls with their arched doorways are an inspiration to just about every artist I know. If you haven't had a chance to study these magnificent structures in person, I highly recommend you take a research trip out west, with a camera and sketch pad in hand.

These buildings can be a challenge to paint, especially in this case because of the long stone pathway. This is an ellipse problem that can be a challenging problem even for experienced artists. I will attempt to explain and demonstrate what an ellipse is and how it works before getting started on the painting itself. This is a great painting to experience. Good luck, and, as always, have fun!

Drawing Ellipses

An ellipse is an optical illusion. A round, circular or even a square object that is turned sideways, angled, or is laying down takes on the appearance of an oval or elliptical shape. The best way to clarify this is to show an example. You will need to understand how to draw ellipses for this painting.

Example I

This example shows how a circle becomes an ellipse, and the shape depends on the angle at which it's being viewed by the spectator.

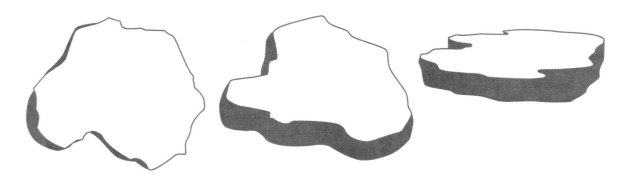

Example II

In the painting *Home from the Market*, the stones on the pathway are all ellipses. The optical illusion here is that when the stone is standing up facing the viewer (far left), it takes on a certain shape; but the same stone lying down looks completely different, more like a true ellipse (far right).

1 Underpaint Sky

For this painting you will need to paint the sky first before making your sketch. This will be a clean, cheerful background color. Load your hake brush with plenty of gesso, start at the horizon and streak it across the base of the sky, using enough water so that it is nice and creamy. Now double-load your brush with yellow and orange and also streak it over the gesso. You don't need to blend this. Now rinse your brush and repeat this step at the top, except after the white gesso, streak on blue, purple and a touch of Burnt Sienna. Quickly blend the base and the top of the sky together so that there is no hard edge.

2 Accent the Sky

Call this whatever you want: clouds, accenting or highlighting. First be sure your underpainted sky is completely dry. Now with your no. 10 or no. 6 bristle brush, scrub in the appropriate highlight for your painting. Most likely the color will be a whitish orange or yellow combination. As you can see, this adds a clean and crisp feel to the sky.

3 Make Charcoal Sketch

Okay, now you can sketch in the main components of the painting, paying special attention to the perspective of the pathway and wall.

4 Underpaint Background Trees

You can create a couple of different trees here. Pine or cedar trees work well for this along with a few bushy trees. For this step, use a no. 6 bristle brush and a mixture of white, purple and green. Of course, this should vary depending on your particular color scheme and value system, so adjust the color accordingly. The main purpose of the trees is to build sort of a framework around the mission.

5 Underpaint Mission and Wall

This is a fairly quick step. Mix a large amount of white, Burnt Sienna and touches of purple and yellow to make a very earthy color. You want to mix plenty of this color because it will be used to underpaint the mission as well as the wall. Use your no. 6 bristle brush with this mixture to scrub in the shape of the mission. For the darker shadowed areas, add a touch of purple to the mixture and switch to your no. 4 flat sable. While you are at it, go ahead and underpaint the wall. Notice that as you come forward, the value gets darker. Also, be sure that the canvas is completely covered in these areas.

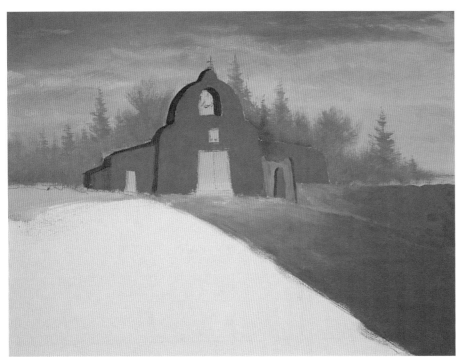

6 Underpaint the Pathway

This step is very similar to the previous one, except you will need to gray the mixture by adding a little blue and a touch of purple. Starting back at the mission, use your no. 6 bristle brush to begin blocking in the pathway. Add touches of white at first, and then as you come forward, decrease the amount of white until you are using the mixture in its pure form. As before, be sure the canvas is well covered.

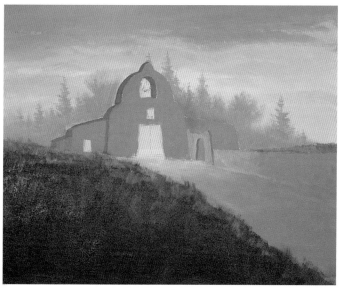

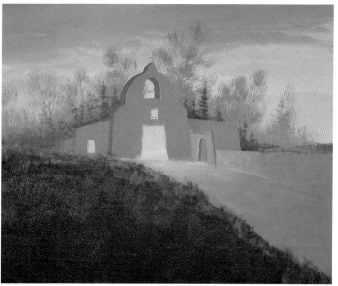

7 Underpaint Wild Flowers

This step is not difficult at all. Just use your no. 10 bristle brush with a mixture of Hooker's Green, purple and Burnt Sienna to block in the entire area, making sure that it is very well covered with paint. Lighten the color a little bit with some Thalo Yellow-Green and a touch of white and do the same thing to the small area of grass on the other side of the wall. Add a little of this lighter green to the edge of the large flower plot to soften and add depth to this area. Now the entire painting is blocked in.

8 Detail the Background Trees

First, with your no. 4 liner brush, mix a medium gray of Hooker's Green, touches of purple and white, and maybe a little Burnt Sienna and paint in a few tree limbs. Experiment with these colors and values to find just the right formula for your particular color scheme. Scumble in a few leaves to give the background a more finished look. After you have placed the large leafy trees, block in a few cedar or pine trees to create some contrast. You will highlight these trees later.

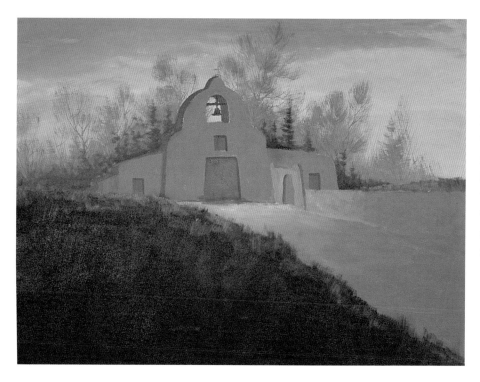

9 Paint In Doors, Windows and Bell

This is another fairly simple step. Just block in the bell with a little Burnt Umber and a touch of white. Either of your small sable brushes will work best here. Then use a medium gray mixture of Burnt Sienna, blue, purple and a little white to block in the doors and windows. Feel free to rearrange the doors and windows to better fit the shape of your building.

10 Highlight Mission, Phase One

I think you'll find this step is a lot of fun. The mission should have the look of hand-finished adobe. First, mix a very light adobe color of white, yellow and just a touch of Burnt Sienna. Load a small amount of paint on the side of your no. 6 bristle brush and use loose dry-brush, scumbling strokes to apply the highlight color to the mission building. It's important to let some of the background show through, so that the surface will look a bit rough. Repeat this step if you need a bit more coverage.

11 Detail the Wall

The wall is in shadow, so it won't be highlighted except on the very top. This is an adobe wall, so our main focus here is to rough it up, to make it look like weathered adobe. The no. 4 flat sable works best for this. Start at the back of the wall and begin drybrushing in various earth tones of Burnt Sienna, yellow, touches of orange and purple and of course a little white. You will do some scrubbing, so if you have an old worn out no. 4 sable, use it; otherwise, you will destroy a new one. Let some of the background show through here as on the mission. Now, with a little of the adobe highlight color, put a cap highlight on the top of the wall, and on the side of the gate.

12 Block In Large Tree Trunk

This is a very quick and fairly easy step. You will be blocking in the large tree, keeping in mind the composition and paying close attention to the arrangement of negative space. If you need to first make a very light sketch with your charcoal, go ahead. You can do most of the painting with your script liner brush, although you may switch to your no. 4 round sable for the main trunk. Make an ink-like mixture of Burnt Umber and water and begin creating the main trunk and then taper out to the smaller branches.

13 Leaf the Large Trees

For this step, start by mixing Hooker's Green, Burnt Sienna and a touch of purple. Add a little white to change the value if needed for your color scheme. Now with your no. 6 bristle brush, begin painting clumps of leaves using a combination of dry-brush, scumbling strokes and some dabbing strokes. The main thing to remember here is to keep the edges of each clump soft and create good negative space. Creating a good underpainting using these basic techniques always makes the following steps easier.

14 Detail Doors, Windows and Miscellaneous Details

Start by making two mixtures: Burnt Sienna with a touch of blue for the dark mixture, and white with a touch of yellow and orange for the light mixture. You may need to add a little white to the dark mixture to soften it. Now take your no. 4 round or flat sable brush and start adding the details you see here, or create some of your own. These details are important to give the mission its character, just don't overdo it.

15 Highlight the Trees

Most of you have done this step many, many times. The highlight mixture will be white, yellow and a touch of Thalo Yellow-Green. I like to use my no. 6 and no. 10 flat bristle brushes for this step. Rough up the tip of your bristles by dabbing them on your table and then put a small amount of the mixture on the tip and begin dabbing the highlights on the sunlit side of each of the clumps. I suggest that you begin the background first and then strengthen the mixture with a little more Thalo Yellow-Green and use it to highlight the larger tree. You may need to repaint the highlight to make the color as bright as you think it needs to be.

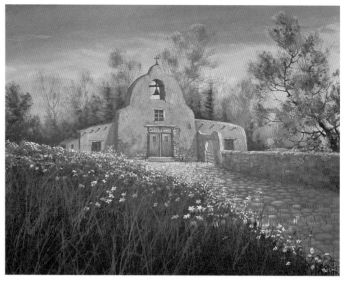

16 Paint the Stone Pathway

This is probably the step that will give you the most trouble. It's not the color or the painting technique that will be the problem, but the shape of each rock. These rocks need to appear as if they are lying flat, so you may want to turn back to the demonstration at the beginning of the project to get the ellipses right. Mix white, orange and a touch of yellow for the highlight color. Now beginning at the base of the mission, block in the rocks. The first few rocks are very small, and as you move forward, the rocks get larger and take on more varied shapes. Also, notice the cracks around each rock, and the variation in value of each rock. You can darken the value by thinning the highlight color to almost a wash; it will dry darker than the areas where the mixture is more opaque and thicker. It may take a little practice to get the hang of doing these rocks, but it is well worth the effort.

17 Paint Flowers, Phase One

The first thing to do here is put in the taller weeds with your script brush and an ink-like mixture of Thalo Yellow-Green, orange and a touch of yellow. Then with your no. 4 flat sable brush, dab on spots of white, yellow, pink, purple, orange and red along with any other color you like for different types of flowers. Begin in the background, and come forward until you have covered about half of the flower plot.

18 Highlight Mission, Phase Two

At first glance it may appear that not much has changed; however, if you look closely, you will see exaggerated highlights, more visible brushstrokes and additional highlights that give the mission its glow. Mix white with a touch of yellow and a little orange. Now hunt for the areas where your mission needs a little more highlight and scrub it in with your no. 6 bristle brush; you may even need to work on the wall or even the pathway. Then mix a bluish color, and put a little on the doors to give the mission a little more interest.

19 Sketch in the Woman

All you need to do here is make a simple, accurate sketch of the woman, making sure she has the right proportions and location.

20 Block in the Woman

Next, simply block in the woman's upper outer garment with a deep bluish gray. Block in her dress with a deep maroon, and the bags she is carrying with a dark brown. Use your no. 4 flat sable for this, and don't get carried away with any details. Be sure the canvas is well covered with paint, and keep the edges soft.

21 Highlight Woman

The best advice I can give you here is to use quick, clean strokes of lighter values of the underpainting colors. For example, take the bluish gray color, add lots of white and then with your no. 4 flat sable brush, quickly stroke on highlights to suggest folds, wrinkles and sunlight. Be sure the background color comes through to create the shadows. If you happen to overhighlight, go back and add more shadow color. Repeat this same procedure on the outer areas of the woman. Finally, add touches of a whitish yellow for the accent highlight on the outer edges of her form.

22 Add Flowers, Phase Two

This is really a fun step, and not much different from step 17. Simply mix up your favorite bright color, and use your no. 4 flat and no. 4 round sable to begin painting in the different flowers, making them much larger and more intense in color and detail as you come forward. The very best advice I have for you here, and I know you are tired of hearing this, is to strive for good composition in terms of negative space. Notice most of the flowers are grouped toward the center of the flower plot, so that your eye flows back toward the mission.

23 Finish Up

You may be completely finished here; however, it is a good idea to step back and scan the painting for anything that bothers you. Try to make any of your minor corrections quickly, so that you can get it out of your mind, and move on to the next painting. Try to avoid overworking your painting by remembering the three *P*'s: Don't piddle, play or putter.

The Bicycle and the Bluebird
16" x 20" (40.6cm x 50.8cm)

The Bicycle and the Bluebird

This is a fairly odd, but very interesting painting. I guess it's best described as a composite of several different technical challenges: composition, design, perspective, value, color and atmosphere, combined with a number of different subjects to create a really fun and challenging painting. Having been born and raised in the Midwest, my first idea of interesting subjects to paint were things like old buildings, barns, fences and other nostalgic items found in rural areas. These are all subjects that I never seem to grow out of. I don't paint these things as much as I used to, but every year they manage to appear on a few of my canvases. This is a great study painting; however, there are some hidden dangers, the main one being making the painting too busy. You may want to change some of the subjects or add others; just be careful not to overdo it. Let's get started!

1 Make Charcoal Sketch
Once again, a simple charcoal sketch is all that is necessary to start this painting on its way.

2 Block In Sky
Since this is a gray, overcast day, the sky should be simple and soft. A mixture of white, a touch of blue, Burnt Sienna and orange will give you just the right color to set the mood for this painting. Since there will be no clouds, paint the background solid with your hake brush. Most likely, you will have to give it a second coat after it dries. The exact color of gray that you end up with is up to you.

3 Underpaint the Background Trees, Phase One
Start with the gray sky color and add a touch more blue and orange. Now with you no. 10 bristle brush, scrub in the first layer of background trees. Notice the softness and the variety of shapes. Because this is just the first layer, keep it simple. Softness and good negative space are your main objectives here.

4 Underpaint Background Trees, Phase Two

All you need to do here is repeat the same procedure as in step 3, after you darken the background tree mixture about two shades. Use your no. 10 or no. 6 bristle brush to scrub in some underbrush at the base of the background trees. Once again, negative space is your main concern.

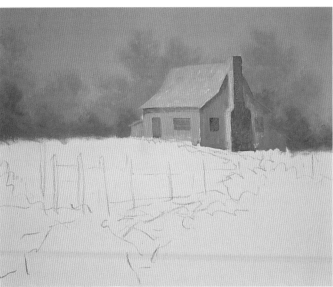

5 Underpaint Cabin

This is a very simple step; however, you need to be fairly accurate with the underpainting, so take all the time you need to get the job done. You will need your no. 6 bristle brush and your no. 4 flat sable and you will mix four basic values for the cabin. I used the background tree mixture we just finished with, and then added touches of Burnt Sienna and purple for the two darker values and touches of white or even a little orange for the two lighter values. There are four basic values: the roof, left side, right side and the chimney and windows. Block in all of these areas, making sure the building is fairly square and is standing up straight. Keep in mind that this is only the underpainting, so it can be a little rough around the edges.

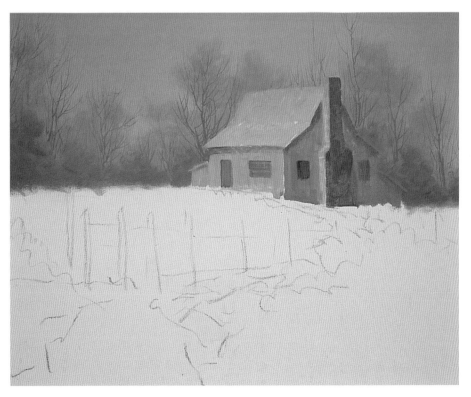

6 Paint Tree Limbs in Background

Now, with your no. 4 script liner brush, create a mixture that is slightly darker than the background trees. Thin it to an ink-like consistency and paint in a few trunks, not too many, and paint in the smaller limbs. These limbs need to be fairly delicate, so be sure to use a very light touch.

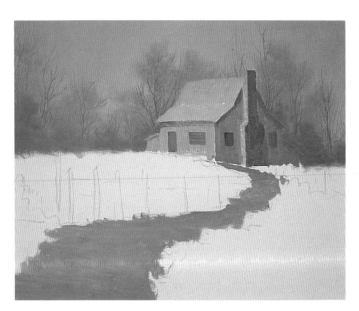

7 Underpaint Pathway

For the pathway, just scrub in a middle gray color that's similar to the sky, a mixture of white, blue, Burnt Sienna and orange. Scrub it on fairly thickly using your no. 6 bristle brush. Notice that the edges are rough and irregular. Also, notice that the pathway is much wider at the front, and narrows as it recedes toward the cabin.

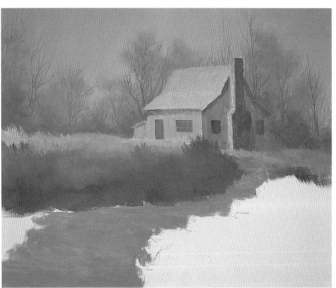

8 Underpaint Grass in Middle Ground

You will need your no. 10 bristle brush and two values of paint for this step. Make a large mixture of yellow, orange and a touch of Burnt Sienna and white for the light value. A mix of Burnt Sienna, purple, blue and a touch of white works great for the dark value. Scrub the light mixture on fairly thickly, and while it is still wet, scrub in the dark value beneath it. Now carefully scrub in the two values together while at the same time creating the suggestion of grass, bushes and other brush.

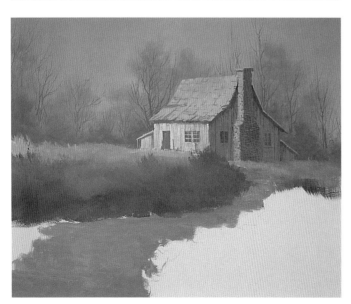

9 Highlight Cabin, Phase One

This is really a detail step; you will use your no. 4 sable brush for most of this. Really, all you do here is create a lighter value of each of the underpainting colors, and then mix it with water until it's creamy. Use gentle vertical strokes to create the suggestion of wood on the front and side of the cabin. For the shingles, use short, choppy strokes, following the angle of the roof. For the chimney, create the suggestion of stones. Now with your no. 4 round sable and a darker mixture, go ahead and add a few accent details to create the suggestion of cracks in the wood, shingles, and between the stones. Don't get carried away with this; you will work on the details later.

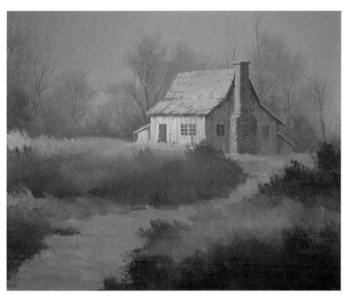

10 Underpaint Foreground Bushes and Grass

This step is almost identical to step 8; but for this step you'll need to be more specific about your bush shapes and your value changes. Notice that things become darker as they come forward. I prefer to use my no. 10 bristle brush for this; however, the no. 6 bristle can give you a little more control for the brush that is closer up. Keep an eye on your negative space, your eye flow and where the sunlight falls on the bushes.

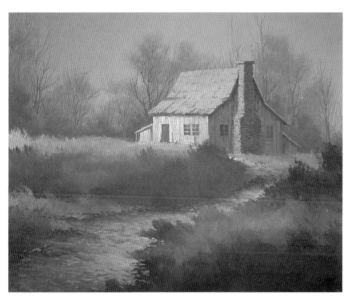

11 Detail the Pathway

For the shadow areas, mix Burnt Sienna, blue and a touch of purple. For the highlight, mix white with a touch of orange and maybe a little Burnt Sienna. To create a dirt pathway, use short, choppy horizontal strokes with a no. 6 bristle brush. Sometimes the no. 4 flat sable works better for the smaller details.

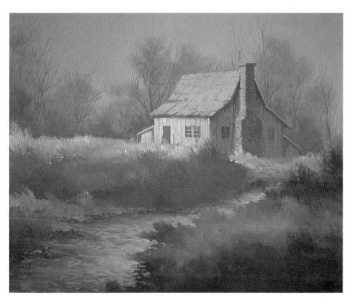

12 Highlight Middle Ground Grasses

This step should not be too difficult. A mixture of white, yellow and a touch of orange is a great highlight color for the grass highlights. Use your no. 6 bristle brush to begin dabbing on the highlights of the grass in the middle ground. Put the paint on fairly thickly so that the highlights will remain clean and bright. It's also important to be fairly selective about where you place the highlights. Pick certain bushes and clumps of grass, and dab on the highlights, so that they stand out. This is a small area, so be careful not to overhighlight or you will lose the contrast.

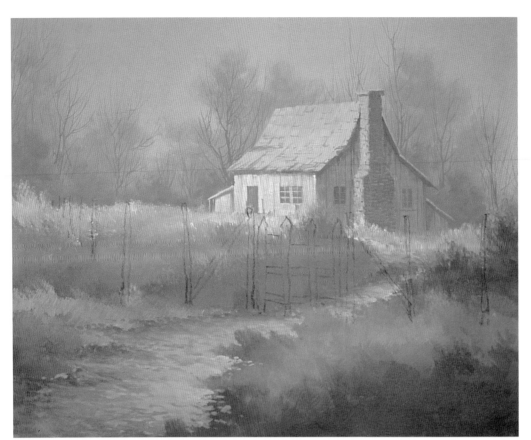

13 Sketch In Fence and Gate

It is important here to be sure that you have a fairly accurate sketch. This is where using the soft vine charcoal comes in handy because you can easily erase it with a damp paper towel. Be sure you are happy with the sketch before proceeding.

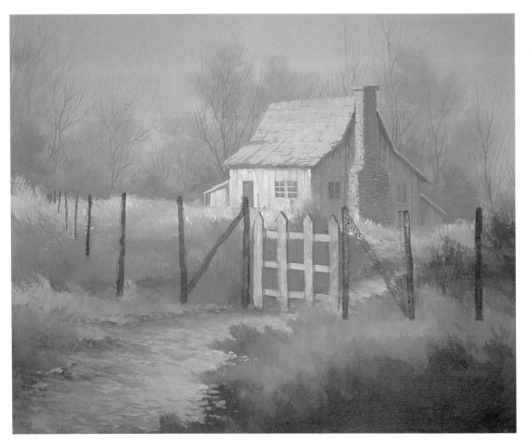

14 Block In Fence and Gate

You will need your no. 4 flat sable brush for this step. Block in the fence posts with a mixture of Burnt Sienna and Ultramarine Blue, and add a little white just for painting the more distant posts. As for the gate, use the post mixture and add more blue and quite a bit of white to create a very light gray. Block in the gate pickets, applying the paint fairly thickly.

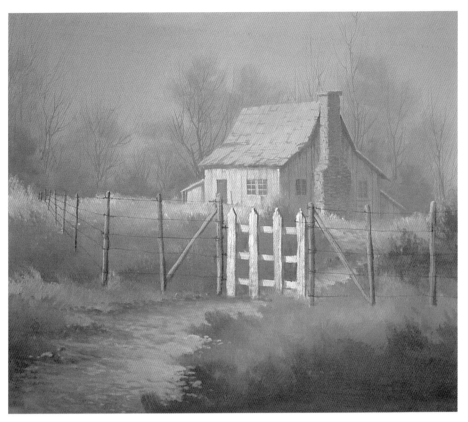

15 Detail Fence and Gate

Now you will add wire, highlights and minor details to the gate. You will need your script liner brush and your no. 4 round sable for this step. First, make an ink-like mixture of Burnt Sienna and blue. Next, carefully paint in the wire, which is more difficult than it looks and requires a very light touch. Have fun highlighting the fence posts with a mixture of white and orange, and simply add more white to the mixture to highlight the pickets on the gate.

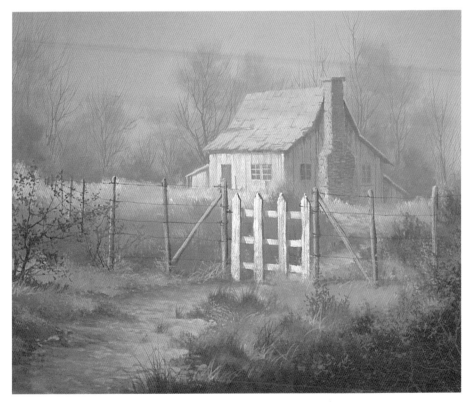

16 Detail Foreground Brush

There is a lot of activity involved in this step, and this is a good place to use your artistic license. You can use a variety of brushes, but mainly your script brush should be used along with your no. 4 round sable and your no. 6 flat bristle. First, block in all the limbs with your script brush, and then with a variety of light or dark values, paint in all of the taller weeds. Remember the contrast rule, light against dark, dark against light. All of the colors in this step are just brighter or darker versions of the colors we have been using. Scrubbing, dabbing and scumbling are the three basic techniques we use to add these details. Don't be afraid to use pure color, like orange or yellow for accenting.

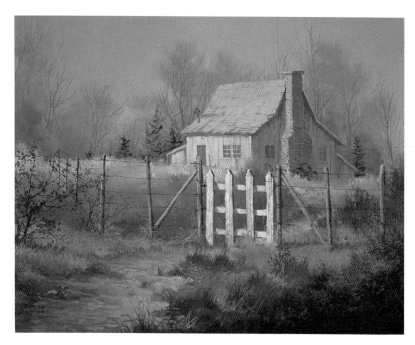

17 **Sketch In Miscellaneous Details**
Once again, feel free to use your artistic license here. I chose to sketch in a bicycle, cedar trees and an eastern bluebird. Any nostalgic items will be appropriate, as long as they don't interfere with the overall composition. You may want to put a slight point on your charcoal to sketch these items.

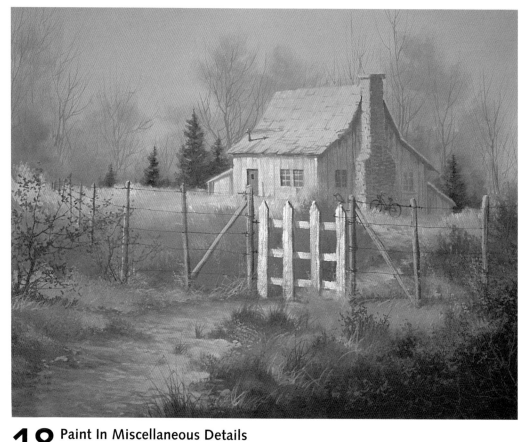

18 **Paint In Miscellaneous Details**
For the cedar trees, mix Burnt Sienna with a touch of blue, maybe a little Hooker's Green and of course, a touch of white to create the right value. Use your no. 6 bristle brush to dab in the trees, which serve to frame the cabin. Use your own judgment for the other objects. Color isn't really an issue here, but the value of the color is; so be sure, wherever you place an object, that the value is correct for its location. By now you should know the value rule for creating depth; however, I will go ahead and give you a brief reminder: As objects recede into the distance they get smaller and less intense in color and value. A grouping of objects will get closer together and, of course, also less intense in color and value.

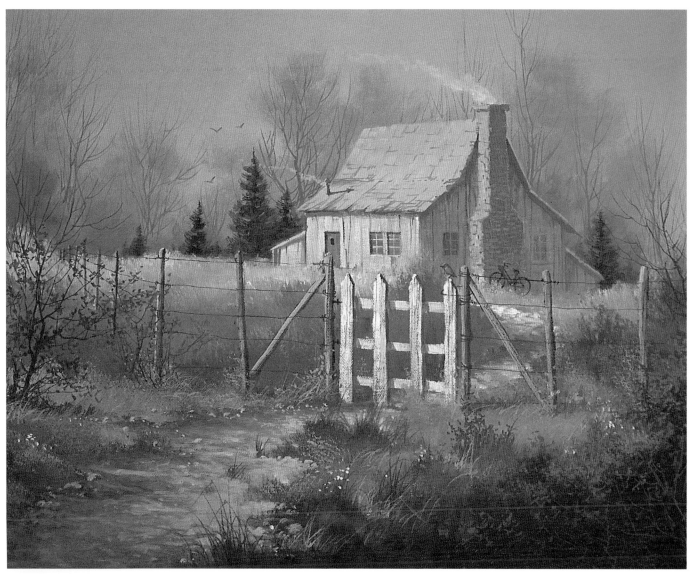

19 Refine the Painting

As is often the case, you may be done by now. As for my painting, I added smoke from the chimney, a few flowers, additional highlights and distant birds. Have fun, just don't overdo it.

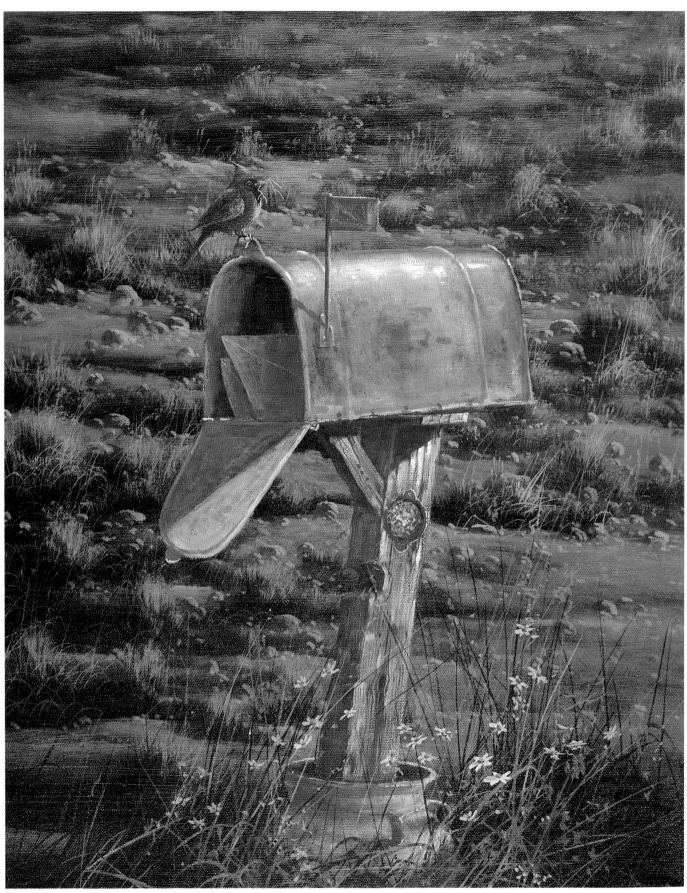

No Vacancy
20" × 16" (50.8cm × 40.6cm)

No Vacancy

Another memory was the inspiration for this painting. A few years ago, we moved to a small farm in eastern Oklahoma. Out by the entrance of our driveway was a huge oversized mailbox attached to an old weathered post, stuck in a cream can, and sitting on some concrete blocks. The mailbox was overgrown with weeds and wild flowers. All of these things combined make for a wonderful subject; however, what really made it interesting for me was that the mailbox was no longer in use, and the lid was wired shut. One day as I was working in the yard, I noticed a male and female cardinal land on top of the box and tug on the wire. This went on for several days, and I finally figured out that they might be wanting to build a nest. So I removed the wire, opened the lid, and before long they began showing up with twigs and pieces of grass. It didn't take me long to get out there with my camera and sketchpad and plan this painting. The original painting is 4' × 5' (122cm × 152cm). Of course, for this lesson I scaled it down to 16" × 20" (41cm × 51cm). This is a great study in painting metal, weathered wood and other textures. I hope you'll have fun with this one!

1 Underpaint Background, Phase One
This may seem like a very unusual way to start a painting; however, what's needed is a loose, free, horizontally mottled background. Also, this painting is unusual because there is no horizon line; it's all background work. All you do here is use your no. 10 bristle brush and pure Hooker's Green and cover the background with long horizontal strokes. Although there are thick and thin spots, be sure the canvas is completely covered with paint.

2 Underpaint Background, Phase Two
The next step is to create a little contour to the ground by adding some subtle contrasting values of color. Start with Hooker's Green and add touches of Burnt Sienna and white, or even a little touch of purple. Now use a variety of horizontal strokes with your no. 10 bristle brush, creating raised places on the ground to give it an interesting contour. Be sure to allow some of the background to show through to create the needed contrast.

3 Add Clumps of Grass
The placement of the clumps of grass is important to the composition of the painting. Begin by mixing Hooker's Green, a touch of Burnt Sienna and a little purple. Now with your no. 10 bristle brush, begin painting in the clumps of grass, using a vertical dry-brush stroke. I can't stress enough the importance of good use of negative space. Keep in mind the location of the mailbox as you place these clumps. As you can see, the larger clumps are closer to the sides to create "eyestoppers."

4 Highlight Dirt, Phase One

Now the painting begins to come alive. You will mainly use your no. 6 bristle brush and a variety of earth tones here. Make three mixtures: white with a touch of orange, white with touches of Burnt Sienna and yellow, and white with a touch of yellow. You can also create other light earth tones. Begin highlighting these contours or raised places following the existing contours in and around the clumps of grass, but don't make these highlights too bright yet.

5 Sketch In Mailbox

Because the mailbox is the main subject, it is important to accurately sketch its size, proportions, angle and location. Again, the beauty of working with charcoal is that it is easy to remove if needed. Charcoal may not show up very well against the background, so you may want to substitute a white or light-colored Conte pencil.

6 Block In Rocks and Pebbles

This is really not a difficult step, but it's an exercise in composition to arrange the pebbles and rocks with good negative space. Keep in mind that these pebbles are not the feature, they only accent and complete your background. Block in the rocks with your no. 4 flat sable with a mixture of Burnt Sienna, Ultramarine Blue and a touch of purple. Keep in mind that the sunlight comes in from the right side of the painting, so the shadowed sides of the pebbles are on the left. My advice is that once you have the pebbles blocked in, you should check to see if they interfere with the overall composition. If so, now is the time to make any adjustments.

8 Highlight Grass

For the grass highlights, create mixtures of Thalo Yellow-Green and a touch of orange, Thalo Yellow-Green with a touch of white, and Thalo Yellow-Green with a touch of yellow. Highlighting the grass here requires quick, clean, vertical strokes with your no. 6 or no. 10 bristle brush. Don't be afraid to experiment with different highlight colors. Notice that the highlights are mostly on the tops of the grass clumps.

7 Highlight Rocks and Pebbles

Once your rocks and pebbles are blocked in, add white and a little touch of orange to the color from step 6. Use your no. 4 flat sable brush to quickly highlight the top right side of each rock. If your highlight color is too dull, just add more white and orange, or even a touch of yellow. You may need to go over the highlight two or three times; however, keep in mind that the final highlights are applied in the final step.

9 Add Flowers and Weeds

Next, take the highlight colors from the previous step, thin them down to an ink-like consistency, and use your script liner brush to paint in the taller weeds. Once again, be selective about their placement; they play an important part in the composition. The flowers are simply accents, and you can make them any color you like. With your no. 6 or no. 10 bristle brush, dab in enough flowers to create a good balance of contrast and complements.

10 Block In Mailbox

The next few steps are very quick and easy, so you will be able to fly right on through them. For this step you want to mix Burnt Sienna, Ultramarine Blue and a touch of purple. Use your no. 6 bristle brush to completely cover the outer and inner parts of the mailbox. Be sure you have good coverage, and lighten the outside just a little bit. The mixture should be creamy. Add a little white to change the value for the outside.

11 Block In Post

In this step, use the same basic mixture as in the above step. Add a touch of white to slightly change the value, and block in the light side of the post. Then add a little more blue and Burnt Sienna to darken the mixture for the shadowed side. You should have two distinct values that show a dark and a light side. Now take the dark value, and add a dab in a few dark areas to suggest old weathered wood. Use your no. 4 flat sable or no. 6 bristle for this step.

12 Block In Cream Can

This step will make the cream can appear round. This is nothing more than a basic blending technique. With your no. 4 flat sable, begin at the center of the can with a mixture of Burnt Sienna and touches of blue, purple and white. Use a series of flat scumbling strokes. As you work out toward the edges, add more white directly on the canvas. Since this is an old weathered can, your brushstrokes should be visible to suggest the old, dented, weathered look. Now simply fill in the inside of the can with your dark mixture.

13 Detail Mailbox

Creating the effect of old, weathered metal creates a challenge even for the most seasoned artist. I will explain how I do it, but it is going to take some experimenting on your part. I take my no. 6 bristle brush and mix a base color of white with a touch of yellow. As I start scrubbing in this base color I add very small touches of Burnt Sienna, red, blue and green; look closely and you can see all of these colors in the mailbox. Most likely, you will have to apply two or three layers to get the effect you're after. The final layer is a very bright opaque whitish yellow at the top of the mailbox, just before it curves over to the other side. You can see how the subtle light and dark contrasts create the suggestion of dents or raised areas. Last, with the whitish yellow highlight, accent the rim and outer edges of the mailbox and lid.

14 Detail Post

This is a fun step because I love to paint weathered wood. The best color to use here is white with a touch of orange applied with a dry-brush technique. Load the tip of your no. 4 bristle brush and gently drag the brush downward over the underpainting with a little bit of wiggle, creating the suggestion of woodgrain. Now with your script liner brush and dark mixture of blue and Burnt Sienna, and of course enough water to thin it, add details such as cracks, knots and holes. Finally just have fun adding minor details that you find interesting.

15 Detail Cream Can

In this step you will add minor highlights and the handles to the cream can. I suggest you sketch in the handles with your charcoal, and then use the colors from step 14 to block in the handles, and add highlights with the whitish orange mixture. These details are best accomplished with your sable brushes. Once again, add whatever highlights and details that will best finish out your cream can.

16 Add Foreground Grass

This step should be second nature to you by now. Mix up a variety of light and dark grass colors, and as usual, add water to make the mixture ink-like. Use your script liner brush with long, deliberate strokes to first paint the darker weeds, then add the lighter colored weeds. Notice that there are lots of weeds of differing lengths that overlap each other, which creates a good composition around the base of the cream can.

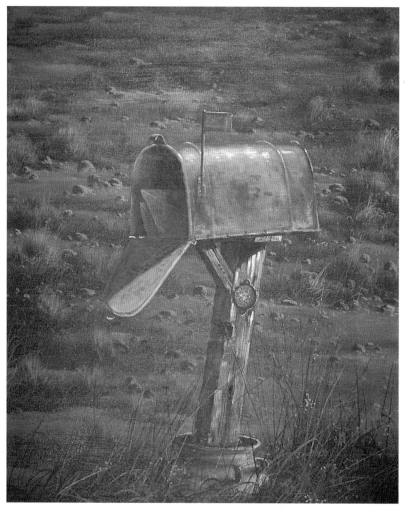

17 Add Miscellaneous Details

Here you will add the fun details such as the latch, the flag and the reflector. Your sable brushes work best for just about all of your detail work. Underpaint the red objects with a mixture of purple and red, then paint over them with pure red and also perhaps a touch of white to give the color a clean, opaque, intense look. For the other items, use a highlight mixture of white and orange for light details, and blue with Burnt Sienna for darker details. However, do not hesitate to experiment with different values of these two mixtures to finish out the details. Putting some letters inside the box is a nice touch; but if you would rather put a nest in there, be my guest.

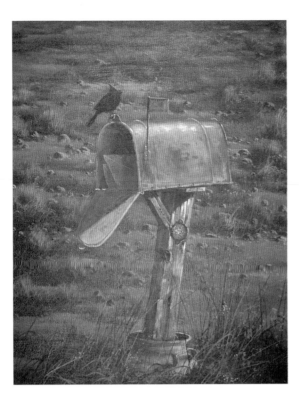

18 Underpaint Cardinal

The first thing you need to do here is make an accurate sketch of the cardinal, and then mix red and purple for the underpainting color. Use your no. 4 flat and round sable brushes to completely block in the cardinal. Be sure the outer edges of the body are soft. The soft edges at this stage will make applying the finishing highlight colors much easier, and will keep the bird from looking cut out and pasted on.

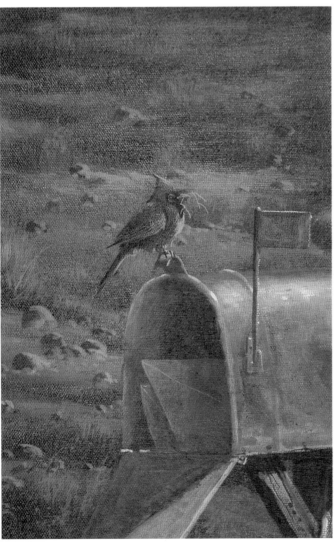

19 Detail Cardinal

This step requires a fairly steady hand; in fact, when I paint most of my wildlife, I use a mahlstick and my Stedi Rest (see page 18 for a demonstration of these tools). For the details on the cardinal, mix a creamy mixture of red and a touch of white. Take your no. 4 round sable brush, spread out the bristles a little bit, lightly load the brush and carefully drybrush on the highlights. This takes some practice. Next, add a little more white and a touch of yellow to the red mixture, and put on the final highlights to accent the bird. If you happen to make a mistake, or are not satisfied with your result, just use the dark mixture to paint out that area and start over.

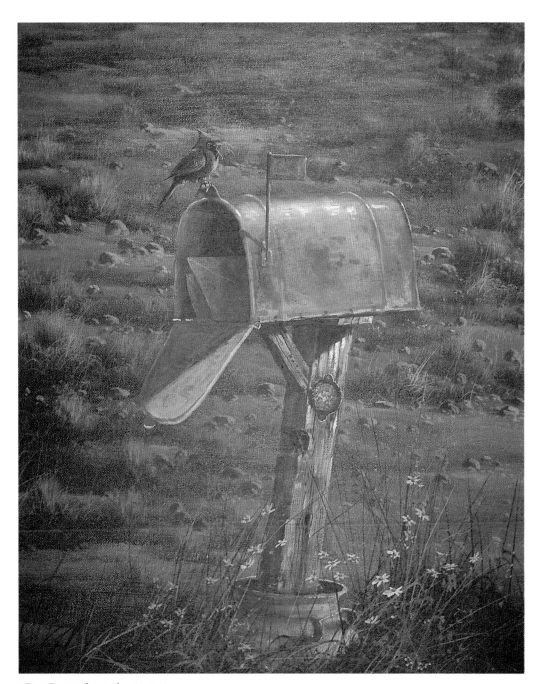

20 Refine the Painting

In this final step, I am going to turn you loose with your own "artistic license" to add touches to this painting that will make it your own. Some of the things you might consider adding are flowers, brighter highlights on the mailbox and cardinal, and maybe a few more weeds; but the most important decision you can make is when to quit before you overwork it.

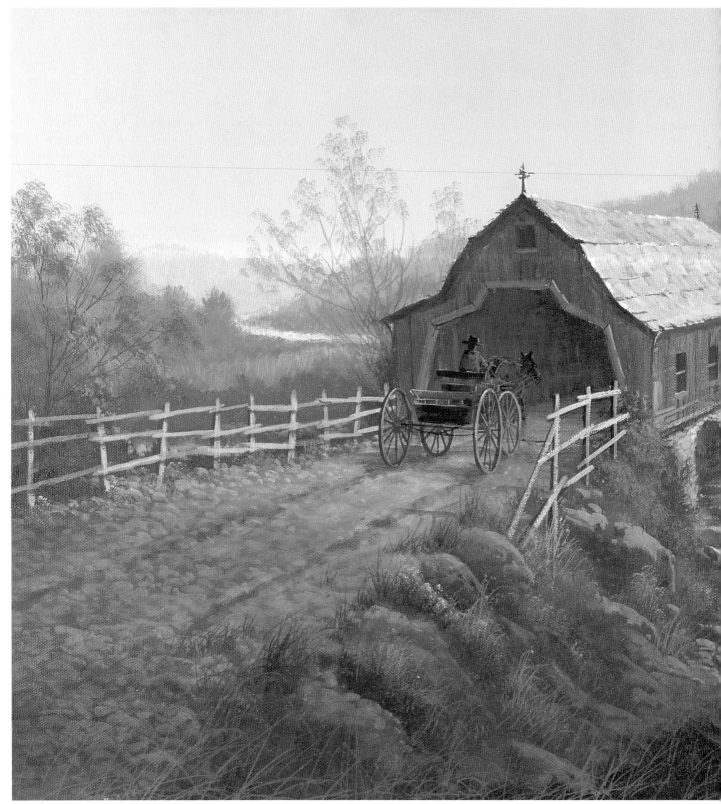

Return to Days of Old
16" × 20" (40.6cm × 50.8cm)

Return to Days of Old

The covered bridge is a wonderful piece of American architecture that still continues to enhance the landscape, especially in the eastern states. I have done a number of covered bridge paintings, each with its own set of challenges, and this one is no different. The main challenge here is perspective. Most covered bridges are long and skinny, and many of them have unique angles and designs that really add to the challenge of creating proper perspective. Although it looks simple, this is a fairly difficult painting. The best advice that I can give you is to work out the perspective of the bridge in relation to the creek and the road. I usually sketch this out full scale on my drawing pad to be absolutely sure that everything is correct. Sketching the bridge requires an understanding of one-point perspective, and it would be well worth your time to do a little review of this technique. You can find good reference material in books in any art supply store.

1 Make Charcoal Sketch

An extremely accurate sketch is not necessary for most landscapes; however in this case, because of the perspective of the bridge and the unique arrangement of the landscape, a fairly accurate sketch is called for.

2 Block In Sky

This is a very simple sky. Simply apply a generous coat of gesso with your hake brush. While the gesso is still wet, add touches of yellow and orange and blend the colors until you have a good, clean, opaque sky. The other option here is to mix this color on your palette and then apply it directly to the sky. I happen to prefer to mix the colors on the canvas, but either way is fine.

3 Block In Distant Hills

Take a little of the sky color and add a touch of purple. Use this color and your no. 6 bristle brush to scrub in the first distant hill. Next, darken the color with a touch of blue, Burnt Sienna and a little more purple. Scrub this next layer in, and notice that I left the top of the hill fairly rough to suggest a tree-covered hill.

4 Block In Middle Ground Trees

Take the hill color you just used and add a little more purple and a touch of Hooker's Green. Be sure the value is two or three shades darker than the hill. Use your no. 10 bristle brush to dab in the trees in the middle-ground. It's important now to be mindful of the negative space by giving your trees good shapes and forms. Notice that I left a small area blank where the pond will go.

5 Block In Middle Ground

This step is only the underpainting, so you will use your no. 10 and no. 6 bristle brushes to scrub in and scumble in the middle ground area with loose, haphazard strokes just to suggest bushes, brush and grass. The mixture is a combination of yellow, purple, Hooker's Green and Burnt Sienna; notice that the overall color is rather brownish green. Add touches of yellow or white scattered in now and then to create subtle, contrasting light areas.

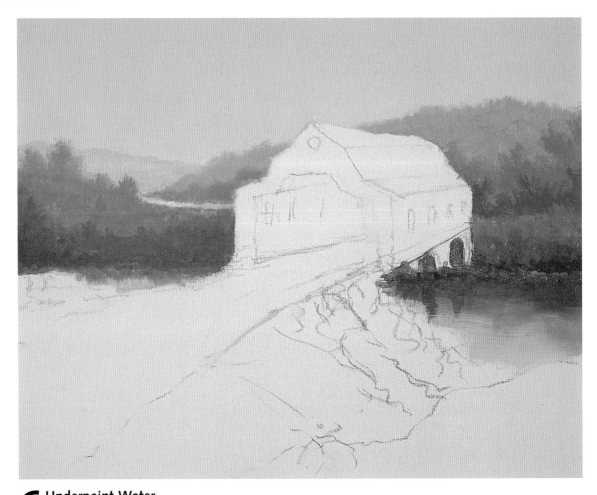

6 Underpaint Water

For this step, take the underpainting color from step two, and darken with a little more purple and Burnt Sienna. Use your no. 6 bristle brush to scrub a fairly thick line of color along the shoreline, then while it's still wet, begin scrubbing downward into the water. As you move downward into the water, begin adding touches of yellow and white until you have covered the water area. If you don't get good coverage with the first layer, let it dry and repeat this step. Keep all of your edges soft.

7 Block In Bridge

This is where an accurate sketch of the bridge is important. I use my no. 4 flat sable brush for blocking in the bridge. Start with the roof. Mix white with a touch of Burnt Sienna, a little blue and purple. This should be a fairly light value for the sunlit side. Use this color to block in the roof. Next, mix blue, Burnt Sienna and purple and block in all of the very dark areas of the bridge. Now mix Cadmium Red Light and a little purple and/or blue to paint the front of the bridge. Use the same color combination with less purple for the side of the bridge. Use the roof color for the bridge supports. This is a good time to square up the bridge and make sure most of your angles are correct.

8 Underpaint Foreground

This is a fairly simple step. You will underpaint two different areas: the eroded bank next to the road and the bushes next to the shoreline and in the immediate foreground. The color mixture is Burnt Sienna and touches of blue with a touch of white to slightly lighten it. First, scrub in the bank area. Then darken the mixture with a touch of Hooker's Green and purple, and scrub in the darker bushes in the foreground. This should be a fairly solid coverage, so don't hesitate to give it a second layer if necessary.

9 Underpaint Road

For this step you will use a mixture of white with touches of Burnt Sienna and purple for the lighter areas of the road. Begin at the back of the road near the bridge and come forward, using short, choppy strokes with your no. 6 bristle brush. As you come forward, begin adding more Burnt Sienna and purple until you reach the foreground. Notice how I put some of the lighter color down the eroded side of the road to suggest rocks and dirt. Everything should be loose and choppy at this stage

10 Highlight Middle Ground Trees

The painting will really begin to take shape with this step. Use your no. 6 bristle brush and several highlight colors to highlight the trees in the middle ground. I used four different mixtures: Thalo Yellow-Green with a touch of yellow, Thalo Yellow-Green with a touch of orange, Thalo Yellow-Green with a touch of white and Thalo Yellow-Green with a touch of Burnt Sienna. Thalo Yellow-Green alone works well for a highlight if you don't overdo it. Use several different strokes or combinations of strokes (scumbling, dabbing and dry-brushing) to gently highlight the background trees, giving them defined, yet subtle highlights and forms.

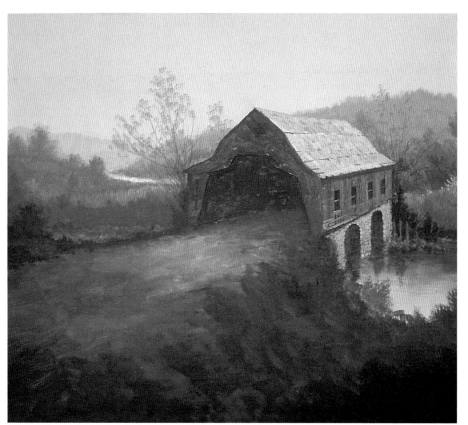

11 Highlight Right Side of Bridge

Now you will begin detailing the bridge. Enhance the sunlight on the right side of the bridge with a mixture of Cadmium Red Light and a touch of white. Use your no. 4 flat sable to drybrush vertical strokes to suggest weathered wood and to enhance the red highlight. Now create a shadow color of a little purple and Burnt Sienna to paint in the overhang shadow from the roof. Next, thin this color with water to use with your script liner brush for adding cracks and other details. Use the no. 4 flat sable brush with a mixture of white with touches of yellow and orange to suggest shingles. Add a few cracks and miscellaneous details to the shingles with the script brush and the dark mixture.

12 Detail Front of Bridge

The technique for these details is identical to step 11. The difference is that this is the shadowed side, so all of the details are a subdued color. You will need to use your no. 4 flat and sable brushes and maybe even your script liner brush. First and most important, add the shadow at the overhang of the roof. Detail the door with the trim work, and add a few vertical boards inside the opening. The main objective to keep in mind is to use grayed tones and be very suggestive.

13 Detail Road

This is one of my favorite steps. Begin with a mixture of white and a touch of orange and/or yellow. With your no. 4 flat sable brush, begin at the opening of the bridge and use a series of long horizontal strokes to suggest the wooden floor of the bridge. As you come forward, begin using short, choppy strokes to suggest dirt, pebbles and rocks. Notice that the road gets darker as it comes forward; this is accomplished by allowing more of the background to show through, plus you can darken the mixture with a touch of Burnt Sienna. Next, highlight the eroded side of the road. You have to be creative here to suggest cracks, crevices and rocks embedded in the dirt on the side of the road.

14 Detail Lower Right Foreground

This part of the painting can truly challenge you. You have a variety of objects to deal with (rocks, grass, bushes, highlights, etc.). The best place to begin is with the rocks. Mix white with a touch of orange, and use your no. 4 flat sable brush to define the forms of your rocks with good, clean highlights. Next, add Thalo Yellow-Green to the mixture, and use your no. 6 bristle brush to dab in the highlights of the bushes. Next, adjust the color by adding more yellow, orange or whatever color you feel is appropriate to dry-brush in patches of grass around the rocks to "settle them down." Once again, this is a great place to use your artistic imagination by adding more rocks, bushes and highlights. The main thing is good composition and tonal value as you finish this section.

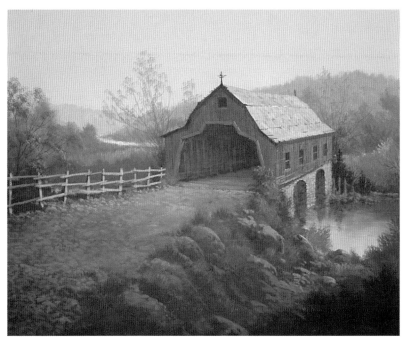

15 Detail Left Side of Road

This step is similar to the previous one. The first thing we do here is take some of the foliage colors we have been using throughout the painting. I almost always use a bristle brush for most foliage because the bristles can be spread out to create a variety of textures. Use some of the foliage colors you have already been using to add leaves to the tree behind the fence. Then highlight the underbrush. Finally, sketch in the fence with your charcoal, then use a light gray color to block in the fence with your no. 4 round sable brush.

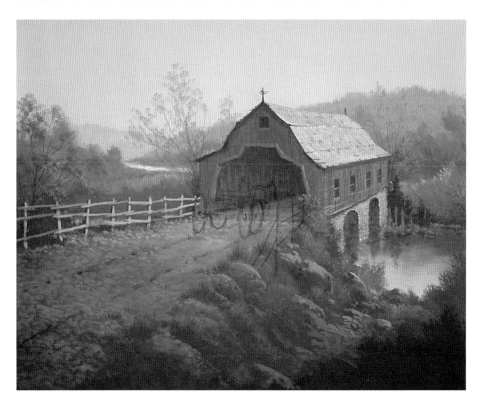

16 Sketch the Remaining Details

No surprise here; use your charcoal to sketch in the horse and buggy, ruts in the road, the fence on the right side of the road and anything else that you want to add. Don't be afraid to add whatever objects you feel will enhance your composition.

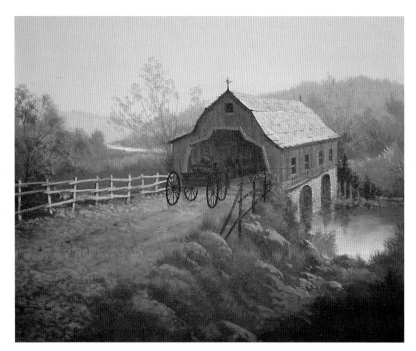

17 Block In the Buggy

Once you feel comfortable with your sketch, mix a creamy mixture of Burnt Sienna and Ultramarine Blue and use your no. 4 round sable brush to carefully underpaint the buggy. You might want to use a Stedi Rest and a mahlstick to steady your hand. See page 18 for an example. Finally, slightly lighten the mixture with a little white and block in the fence.

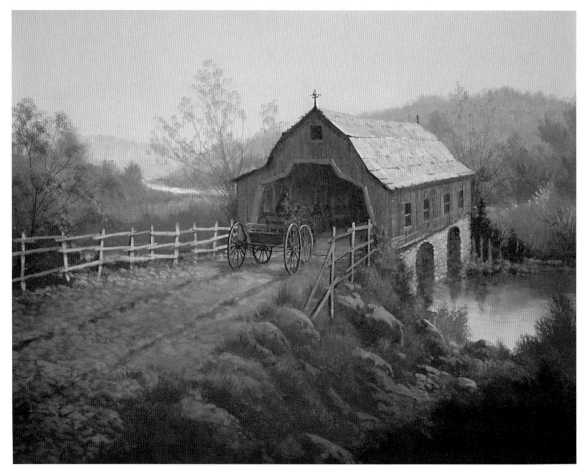

18 Highlight Buggy and Final Details

The main objective here is to highlight the buggy to give it three-dimensional form. Mix white with touches of blue and orange. Now use your no. 4 round sable brush to highlight the buggy. Next, use the same color to highlight the fence. Then mix a little Burnt Sienna with a touch of purple and use your no. 4 flat sable brush to drybrush in the ruts with jerky, broken brushstrokes. Finally, scrub in a shadow under the wagon with this dark mixture.

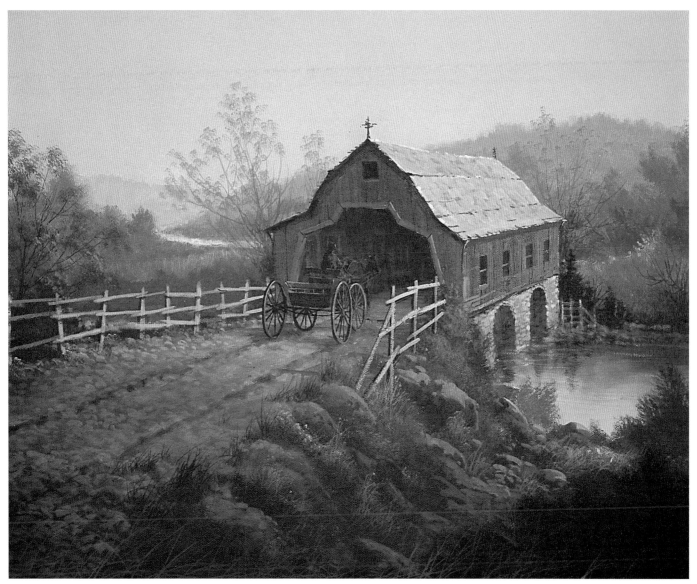

19 Add Final Details

Now you can hunt and fix, adjust, add or even take away anything that is not technically or artistically correct. Just don't piddle, play or putter. You can see I added flowers and additional highlights to give the painting a little more "snap."

I certainly hope you have enjoyed working on the paintings in this book as much as I have enjoyed bringing them to you. For an artist learning new and exciting techniques, subjects and styles, I hope you find this is an adventure that lasts a lifetime. In this book, as in previous books, we have only scratched the surface. I hope you will stay with me as we continue to move forward with more books, videos and workshops. Perhaps someday we will meet and be able to work together. Stay inspired, and keep on painting.

Jerry Yarnell

Index

pathway, 86, 90, 98, 99
Patient Fisherman, 32-41
pebbles,
 blocking in, 107
 detailing, 25,
 highlighting, 47, 50, 67, 68,
 108
 underpainting, 67
pencil, conte, 107
people,
 blocking in, 91
 detailing, 29, 31
 highlighting, 92
 sketching, 28, 91
 underpainting, 28
perspective, 115-16

R

Return to Days of Old, 114
 125
road, 120 122, 123
rocks,
 blocking in, 90, 107
 detailing, 25,
 highlighting, 47, 50, 67, 68,
 108
 underpainting, 67
 See also ellipses

S

sailboat, 57, 60
scrubbing, 10
scumbling, 10
shadows, 23, 24, 27, 77
shoreline, 25, 26, 37
sketch,
 beginning, 22, 34, 45, 54,
 64, 74, 96, 116
 conte pencil, 107
 details, 70, 102, 123
 on underpainting, 28, 38, 40,
 48, 57, 100
 wiping off, 100
sky,
 accenting, 55, 85
 blocking in, 44, 96, 116
 underpainting, 54, 85

snow,
 drifting, 30
 highlighting, 24, 30
 piles, 26
 shadowing, 24
 underpainting, 23
spray bottle, 17
Stedi Rest, 18
steps, 76, 77
stone pathway, 86, 90. *See also*
 ellipses
stones, 77, 90. *See also* rocks
Stone Wall, The, 72-81
sunlight, 78
sunrays, 66, 69
supplies, 16-18

T

Tossed by the Waves, 52-61
tracks, 28
trees,
 blocking in, 38, 45, 66, 68,
 117
dead, 38, 48
detailing, 49, 65, 87
highlighting, 24, 37, 46, 89,
 120
layering, 34, 35, 65, 75
leaves, 69, 79, 80, 89
limbs, 35, 68, 75, 97
 pine, 22-24
 shadows, 23
 trunks, 75, 78, 88
 underpainting, 64, 74, 96, 97
 values, 64-65
triple load, 8

U

underbrush, 25, 39, 46, 75,
 101
underpainting, 10
See also under individual
 entries

V

value, 10

W

wall, 76, 77
wash, 9
water,
 adding light, 36
 brightening, 37
 changing value, 55
 choppy dark edge, 25
 detailing, 58
 highlighting, 37, 56, 60, 69
 lightening, 30
 overhighlighting, 68
 reflections, 34, 35, 67
 ripples, 36, 68
 shimmering, 37
 transparent, 25
 underpainting, 22, 34, 55,
 65, 118
waves, 56, 58, 59
weeds, 37, 39, 108
wet-on-dry, 10
wet-on-wet, 10

Painting Has Never Been Easier!

Jerry Yarnell makes painting fun and exciting. He shows you how to transform a blank canvas into a spectacular landscape-even if you've never painted before! In this book, the first in the Paint Along with Jerry Yarnell series, he provides you with ten beautiful landscape projects, including a beautiful snow-covered country road, a secluded forest path, a glorious desert, a quiet lakeside church and more.

ISBN-13: 978-1-58180-036-4, paperback, 128 pages
ISBN-10: 1-58180-036-3, paperback, 128 pages

Here's the reference you've been waiting for! Inside you'll find 28 step-by-step demonstrations that showcase the methods that can help you master the many faces of acrylic painting-from the look of highly controlled transparent watercolor to abstract expressionism, and everything in between. Seven respected painters make each new technique easy to learn, illustrating just how versatile acrylics can be.

ISBN-13: 978-1-58180-175-0, paperback, 128 pages
ISBN-10: 1-58180-175-0, paperback, 128 pages

Painting inspirations. There's no better way to describe the stunning projects provided by Jerry Yarnell in Volume Two of his popular series. As always, his invaluable instructions and encouraging voice accompany each new artistic challenge. It's just the guidance you need to master ten complete step-by-step projects, including a gorgeous Indian village, rocky cliffs, snow-covered hillsides and more.

ISBN-13: 978-1-58180-100-2, paperback, 128 pages
ISBN-10: 1-58180-100-9, paperback, 128 pages

This book is for every painter who has ever wasted hours searching through books and magazines for good reference photos only to find them out of focus, poorly lit or lacking important details. Artist Gary Greene has compiled over 500 gorgeous reference photos of landscapes, all taken with the special needs of the artist in mind. Six demonstrations by a variety of artists show you how to use these reference photos to create gorgeous landscape paintings!

ISBN-13: 978-0-89134-998-3, hardcover, 144 pages
ISBN-10: 0-89134-998-7, hardcover, 144 pages

These books and other fine North Light titles are available from your local art & craft retailer, bookstore, or online supplier.